Essays on Various Subjects - Principally Designed for Young Ladies

The Complete Hannah More

Volume 1

Essays on Various Subjects -
Principally Designed for Young Ladies

By Hannah More

Edited by J.R. Waller, MBA

A publication of

THE
Greater ✒ Heritage
Sound Theology *Intellectual Rigor*
Winter Springs, FL
2021

Essays on Various Subjects - Principally Designed for Young Ladies by Hannah More
First published in 1777, and again in 1835.
This eBook edition first published in February 2021
© 2021 The Greater Heritage

Published by The Greater Heritage
1170 Tree Swallow Dr., Suite 309
Winter Springs, FL 32708

Email: info@thegreaterheritage.com
Website: www.thegreaterheritage.com

Cover Design: Rakel Fairfull
Cover Image: *Portrait of Hannah More* (1876) by John Opie. Used with permission from The Mistress and Fellows, Girton College, Cambridge. University of Cambridge - Girton College, Huntington Road, Girton, Cambridge, CB3 OJG, United Kingdom.
Font(s): Adobe Caslon Pro, Marcellus, MrsEavesPetiteCaps, MrsEavesOT, Piazzolla.

ISBN (PDF): 978-1-953855-21-3
ISBN (EPUB): 978-1-953855-22-0
ISBN (MOBI): 978-1-953855-23-7
ISBN (paperback): 978-1-953855-41-1

1 2 3 4 5 6 7 8 9 10 25 24 23 22 21

As for you, I shall advise you in a few words: aspire only to those virtues that are PECULIAR TO YOUR SEX; follow your natural modesty, and think it your greatest commendation not to be talked of one way or the other.

-Oration of Pericles to the Athenian Women

Contents

To Mrs. Montagu

MADAM,[1]

If you were only one of the finest writers of your time, you would probably have escaped the trouble of this address, which is drawn on you, less by the lustre of your understanding, than by the amiable qualities of your heart.

As the following pages are written with an humble but earnest wish to promote the interests of virtue, as far as the very limited abilities of the author allow, there is, I flatter myself, a peculiar propriety in inscribing them to you, madam, who, while your works convey instruction and delight to the best informed of the other sex, furnish, by your conduct, an admirable pattern of life and manners to your own. And I can with truth remark, that those graces of conversation, which would be the first praise of almost any other character, constitute but an inferior part of yours.

> I am, madam,
> > With the highest esteem,
> > > Your most obedient, humble servant,
> > > > HANNAH MORE.

1 This ingenious lady's maiden name was Robinson, and her brother was the eccentric lord Rokeby. She died in 1800, having been a widow many years. Her correspondence exhibits abundant proof of the goodness of her heart, as her "Essay on Shakspeare" does of taste and accomplishments. –ED.

Introduction

IT is with the utmost diffidence that the following pages are submitted to the inspection of the public: yet, however the limited abilities of the author may have prevented her from succeeding to her wish in the execution of her present attempt, she humbly trusts that the uprightness of her intention will procure it a candid and favorable reception. The following little Essays are chiefly calculated for the younger part of her own sex, who, she flatters herself, will not esteem them the less, because they were written immediately for their service. She by no means pretends to have composed a regular system of morals, or a finished plan of conduct: she has only endeavored to make a few remarks on such circumstances as seemed to her susceptible of some improvement, and on such subjects as she imagined were particularly interesting to young ladies on their first introduction into the world. She hopes they will not be offended, if she has occasionally pointed out certain qualities, and suggested certain

tempers and dispositions, as peculiarly feminine, and hazarded some observations which naturally arose from the subject, on the different characters which mark the sexes. And here, again, she takes the liberty to repeat that these distinctions cannot be too nicely maintained; for besides those important qualities common to both, each sex has its respective, appropriated qualifications, which would cease to be meritorious the instant they ceased to be appropriated. Nature, propriety, and custom, have prescribed certain bounds to each; bounds which the prudent and the candid will never attempt to break down; and, indeed, it would be highly impolitic to annihilate distinctions from which each acquires excellence, and to attempt innovations, by which both would be losers.

Women, therefore, never understand their own interests so little, as when they affect those qualities and accomplishments, from the want of which they derive their highest merit. "The porcelain clay of human kind," says an admired writer, speaking of the sex: greater delicacy evidently implies greater fragility; and this weakness, natural and moral clearly points out the necessity of a superior degree of caution, retirement, and reserve.

If the author may be allowed to keep up the allusion of the poet, just quoted, she would ask if we do not put the finest vases and the costliest images in places of the greatest security, and most remote from any probability of accident or destruction. By being so situated, they find their protection in their weakness, and their safety in their delicacy. This metaphor is far from being used with a design of placing young ladies in a trivial, unimportant light; it is only introduced to insinuate, that where there is more beauty and more weakness, there should be greater circumspection and superior prudence.

Men, on the contrary, are formed for the more public exhibitions on the great theatre of human life. Like the stronger and more substantial wares, they derive no injury, and lose no polish, by being always exposed, and engaged in the constant commerce of the world. It is their proper element, where they respire their natural air, and exert their noblest powers, in situations which call them into action. They were intended by Providence for the bustling scenes of life; to appear terrible in arms, useful in commerce, shining in councils.

The author fears it will be hazarding a very bold remark, in the opinion of many ladies, when she adds, that the female mind, in general, does not appear capable of attaining so high a degree of perfection in science as the male. Yet she hopes to be forgiven, when she observes also, that as it does not seem to derive the chief portion of its excellence from extraordinary abilities of this kind, it is not at all lessened by the imputation of not possessing them. It is readily allowed, that the sex have lively imaginations, and those exquisite perceptions of the beautiful and defective, which come under the denomination of taste. But pretensions to that strength of intellect, which is requisite to penetrate into the abstruser walks of literature, it is presumed they will readily relinquish. There are green pastures, and pleasant valleys, where they may wander with safety to themselves and delight to others. They may cultivate the roses of imagination, and the valuable fruits of morals and criticism; but the steeps of Parnassus, few, comparatively, have attempted to scale with success. And when it is considered, that many languages, and many sciences, must contribute to the perfection of poetical composition, it will appear less strange. The lofty epic, the pointed satire, and the more daring and successful flights of the tragic muse, seem reserved for

the bold adventurers of the other sex.

Nor does this assertion, it is apprehended, at all injure the interests of the women; they have other pretensions on which to value themselves, and other qualities much better calculated to answer their particular purposes. We are enamored of the soft strains of the Sicilian and the Mantuan muse,[1] while, to the sweet notes of the pastoral reed, they sing the contentions of the shepherds, the blessings of love, or the innocent delights of rural life. Has it ever been ascribed to them as a defect, that their Eclogues do not treat of active scenes, of busy cities, and of wasting war? No; their simplicity is their perfection, and they are only blamed when they have too little of it.

On the other hand, the lofty bards who strung their bolder harps to higher measures, and sung the "wrath of Peleus' son," and "man's first disobedience,"[2] have never been censured for want of sweetness and refinement. The sublime, the nervous, and the masculine, characterize their compositions, as the beautiful, the soft, and the delicate, mark those of the others. Grandeur, dignity, and force, distinguish the one species; ease, simplicity, and purity, the other. Both shine from their native, distinct, unborrowed merits, not from those which are foreign, adventitious, and unnatural. Yet those excellences which make up the essential and constituent parts of poetry, they have in common.

Women have generally quicker perceptions; men have juster sentiments. Women consider how things may be prettily said; men, how they may be properly said. In women (young ones at least), speaking accompanies and sometimes precedes reflection; in men, reflection is the antecedent. Women speak to shine or to please; men, to convince or confute. Women admire what is brilliant; men, what is solid. Women prefer an extemporaneous sally

of wit, or a sparkling effusion of fancy, before the most accurate reasoning, or the most laborious investigation of facts. In literary composition, women are pleased with point, turn, and antithesis; men, with observation, and a just deduction of effects from their causes. Women are fond of incident; men, of argument. Women admire passionately; men approve cautiously. One sex will think it betrays a want of feeling to be moderate in their applause; the other will be afraid of exposing a want of judgment by being in raptures with any thing. Men refuse to give way to the emotions they actually feel, while women sometimes affect to be transported beyond what the occasion will justify.

As a further confirmation of what has been advanced on the different bent of the understanding in the sexes, it may be observed, that we have heard of many female wits, but never of one female logician – of many admirable writers of memoirs, but never of one chronologer. In the boundless and aërial regions of romance, and in that fashionable species of composition which succeeded it, and which carries a nearer approximation to the manners of the world, the women cannot be excelled: this imaginary soil they have a peculiar talent for cultivating, because here,

Invention labors more, and judgment less.

The merit of this kind of writing consists in the vraisemblance to real life as to the events themselves, with a certain elevation in the narrative, which places them, if not above what is natural, yet above what is common. It further consists in the art of interesting the tender feelings by a pathetic representation of those minute, endearing, domestic circumstances, which take captive the soul before it has time to shield itself with the armor of reflection. To

amuse, rather than to instruct, or to instruct indirectly by short inferences, drawn from a long concatenation of circumstances, is at once the business of this sort of composition, and one of the characteristics of female genius.[3]

In short, it appears that the mind in each sex has some natural kind of bias, which constitutes a distinction of character, and that the happiness of both depends, in a great measure, on the preservation and observance of this distinction. For where would be the superior pleasure and satisfaction resulting from mixed conversation, if this difference were abolished? If the qualities of both were invariably and exactly the same, no benefit or entertainment would arise from the tedious and insipid uniformity of such an intercourse; whereas, considerable advantages are reaped from a select society of both sexes. The rough angles and asperities of male manners are imperceptibly filed, and gradually worn smooth, by the polishing of female conversation, and the refining of female taste; while the ideas of women acquire strength and solidity, by their associating with sensible, intelligent, and judicious men.

On the whole (even if fame be the object of pursuit), is it not better to succeed as women, than to fail as men? To shine, by walking honorably in the road which nature, custom, and education seem to have marked out, rather than to counteract them all, by moving awkwardly in a path diametrically opposite? To be good originals, rather than bad imitators? – In a word, to be excellent women, rather than indifferent men?

Endnotes - Introduction

1 Theocritus in his Idyls, and Virgil in his Bucolics.

2 Homer in the Iliad, and Milton in Paradise Lost.

3 The author does not apprehend it makes against her GENERAL position, that this nation can boast a female critic, poet, historian, linguist, philosopher, and moralist, equal to most of the other sex. To these particular instances, others might be adduced; but it is presumed, that they only stand as exceptions against the rule, without tending to invalidate the rule itself. [The ladies here indirectly complimented appear to be Mrs. Montagu; Miss Aikin, afterwards Mrs. Barbauld; Mrs. Macaulay; Mrs. Elizabeth Carter; Mrs. Chapone; and perhaps Mrs. Lennox.]-En.

1

On Dissipation

DOGLIE CERTE, ALLEGREZZE INCERTE! *-Petrarca.*

AS an argument in favor of modern manners, it has been pleaded, that the softer vices of luxury and dissipation belong rather to gentle and yielding tempers, than to such as are rugged and ferocious; that they are vices which increase civilization, and tend to promote refinement, and the cultivation of humanity.

But this is an assertion, the truth of which the experience of all ages contradicts. Nero was not less a tyrant for being a fiddler: he[1] who wished the whole Roman people had but one neck, that he might despatch them at a blow, was himself the most debauched man in Rome; and Sydney and Russel were condemned to bleed under the most barbarous, though most dissipated and voluptuous reign, that ever disgraced the annals of Britain. The love of dissipation is, I believe, allowed to be the reigning evil of the present day. It is an evil which many content themselves

with regretting, without seeking to redress. A dissipated life is censured in the very act of dissipation; and prodigality of time is as gravely declaimed against at the card-table as in the pulpit.

The lover of dancing censures the amusements of the theatre for their dulness, and the gamester blames them both for their levity. She, whose whole soul is swallowed up in "opera ecstasies," is astonished that her acquaintance can spend whole nights in preying, like harpies, on the fortunes of their fellow-creatures; while the grave, sober sinner, who passes her pale and anxious vigils in this fashionable sort of pillaging, is no less surprised how the other can waste her precious time in hearing sounds for which she has no taste, in a language she does not understand.

In short, every one seems convinced, that the evil so much complained of does really exist somewhere, though all are inwardly persuaded that it is not with themselves. All desire a general reformation, but few will listen to proposals of particular amendment; the body must be restored, but each limb begs to remain as it is; and accusations which concern all, will be likely to affect none. They think that sin, like matter, is divisible, and that what is scattered among so many, cannot materially affect any one; and thus individuals contribute separately to that evil which they in general lament.

The prevailing manners of an age depend, more than we are aware, or are willing to allow, on the conduct of the women: this is one of the principal hinges on which the great machine of human society turns. Those who allow the influence which female graces have, in contributing to polish the manners of men, would do well to reflect how great an influence female morals must also have on their conduct. How much, then, is it to be regretted, that the British ladies should ever sit down contented to polish, when

they are able to reform, to entertain, when they might instruct, and to dazzle for an hour, when they are candidates for eternity!

Under the dispensation of Mahomet's law, indeed, then mental excellences cannot be expected, because the women are shut out from all opportunities of instruction, and excluded from the endearing pleasures of a delightful and equal society; and, as a charming poet sings, are taught to believe, that

> "_____For their inferior natures,
> Formed to delight, and happy by delighting,
> Heaven has reserved no future paradise,
> But bids them rove the paths of bliss, secure
> Of total death, and careless of hereafter."
>
> *Dr. Johnson's Irene.*

These act consistently in studying none but exterior graces, in cultivating only personal attractions, and in trying to lighten the intolerable burden of time, by the most frivolous and vain amusements. They act in consequence of their own blind belief, and the tyranny of their despotic masters; for they have neither the freedom of a present choice, nor the prospect of a future being.

But in this land of civil and religious liberty, where there is as little despotism exercised over the minds as over the persons of women, they have every liberty of choice, and every opportunity of improvement; and how greatly does this increase their obligation to be exemplary in their general conduct, attentive to the government of their families, and instrumental to the good order of society!

She who is at a loss to find amusements at home, can no

longer apologize for her dissipation abroad, by saying she is deprived of the benefit and the pleasure of books; and she who regrets being doomed to a state of dark and gloomy ignorance, by the injustice or tyranny of the men, complains of an evil which does not exist.

It is a question frequently in the mouths of illiterate and dissipated females – "What good is there in reading? To what end does it conduce?" It is, however, too obvious to need insisting on, that unless perverted, as the best things may be, reading answers many excellent purposes beside the great leading one; and is, perhaps, the safest remedy for dissipation. She who dedicates a portion of her leisure to useful reading, feels her mind in a constant progressive state of improvement, whilst the mind of a dissipated woman is continually losing ground. An active spirit rejoiceth, like the sun, to run his daily course; while indolence, like the dial of Ahaz, goes backwards. The advantages which the understanding receives from polite literature, it is not here necessary to enumerate; its effects on the moral temper is the present object of consideration. The remark may, perhaps, be thought too strong, but I believe it is true, that, next to religious influences, a habit of study is the most probable preservative of the virtue of young persons. Those who cultivate letters have rarely a strong passion for promiscuous visiting, or dissipated society: study, therefore, induces a relish for domestic life, the most desirable temper in the world for women. Study, as it rescues the mind from an inordinate fondness for gaming, dress, and public amusements, is an economical propensity; for a lady may read at much less expense than she can play at cards: as it requires some application, it gives the mind a habit of industry: as it is a relief against that mental disease, which the French emphatically call

ennui, it cannot fail of being beneficial to the temper and spirits; I mean in the moderate degree in which ladies are supposed to use it: as an enemy to indolence, it becomes a social virtue: as it demands the full exertion of our talents, it grows a rational duty; and when directed to the knowledge of the Supreme Being, and his laws, it rises into an act of religion.

The rage for reformation commonly shows itself in a violent zeal for suppressing what is wrong, rather than in a prudent attention to establish what is right; but we shall never obtain a fair garden merely by rooting up weeds—we must also plant flowers; for the natural richness of the soil we have been clearing will not suffer it to lie barren ; but whether it shall be vainly or beneficially prolific, depends on the culture. What the present age has gained on one side, by a more enlarged and liberal way of thinking, seems to be lost, on the other, by excessive freedom and unbounded indulgence. Knowledge is not, as heretofore, confined to the dull cloister, or the gloomy college, but disseminated, to a certain degree, among both sexes, and almost all ranks. The only misfortune is, that these opportunities do not seem to be so wisely improved, or turned to so good an account as might be wished. Books of a pernicious, idle, and frivolous sort, are too much multiplied; and it is from the very redundancy of them that true knowledge is so scarce, and the habit of dissipation so much increased.

It has been remarked, that the prevailing character of the present age is not that of gross immorality; but if this is meant of those in the higher walks of life, it is easy to discern, that there can be but little merit in abstaining from crimes which there is but little temptation to commit. It is, however, to be feared, that a gradual defection from piety will in time draw after it all

the bad consequences of more active vice; for whether mounds and fences are suddenly destroyed by a sweeping torrent, or worn away through gradual neglect, the effect is equally destructive. As a rapid fever and a consuming hectic are alike fatal to our natural health, so are flagrant immorality and torpid indolence to our moral well-being.

The philosophical doctrine of the slow recession of bodies from the sun, is a lively image of the reluctance with which we first abandon the light of virtue. The beginning of folly, and the first entrance on a dissipated life, costs some pangs to a well-disposed heart; but it is surprising to see how soon the progress ceases to be impeded by reflection, or slackened by remorse. For it is in moral as in natural things, the motion in minds as well as bodies is accelerated by a nearer approach to the centre to which they are tending. If we recede slowly at first setting out, we advance rapidly in our future course; and to have begun to be wrong, is already to have made a great progress.

A constant habit of amusement relaxes the tone of the mind, and renders it totally incapable of application, study, or virtue. Dissipation not only indisposes its votaries to every thing useful and excellent, but disqualifies them for the enjoyment of pleasure itself. It softens the soul so much, that the most superficial employment becomes a labor, and the slightest inconvenience an agony. The luxurious Sybarite must have lost all sense of real enjoyment, and all relish for true gratification, before he complained that he could not sleep, because the rose-leaves lay double under him.

Luxury and dissipation, soft and gentle as their approaches are, and silently as they throw their silken chains about the heart, enslave it more than the most active and turbulent vices. The

mightiest conquerors have been conquered by these unarmed foes: the flowery fetters are fastened before they are felt. The blandishments of Circe were more fatal to the mariners of Ulysses, than the strength of Polypheme, or the brutality of the Læstrigons. Hercules, after he had cleansed the Augean stable, and performed all the other labors enjoined him by Euristheus, found himself a slave to the softnesses of the heart; and he, who wore a club and a lion's skin in the cause of virtue, condescended to the most effeminate employments, to gratify a criminal weakness. Hannibal, who vanquished mighty nations, was himself overcome by the love of pleasure; and he, who despised cold, and want, and danger, and death on the Alps, was conquered and undone by the dissolute indulgences of Capua.

Before the hero of the most beautiful and virtuous romance that ever was written – I mean Telemachus – landed on the island of Cyprus, he unfortunately lost his prudent companion, Mentor, in whom wisdom is so finely personified. At first, he beheld with horror the wanton and dissolute manners of the voluptuous inhabitants; the ill effects of their example were not immediate; he did not fall into the commission of glaring enormities; but his virtue was secretly and imperceptibly undermined, his heart was softened by their pernicious society, and the nerve of resolution was slackened: he every day beheld, with diminished indignation, he worship which was offered to Venus; the disorders of luxury and profaneness became less and less terrible, and the infectious air of the country enfeebled his courage, and relaxed his principles. In short, he had ceased to love virtue long before he thought of committing actual vice; and the duties of a manly piety were burdensome to him before he was so debased as to offer perfumes and burn incense on the altar of the licentious

goddess. [2]

"Let us crown ourselves with rose-buds, before they be withered," said Solomon's libertine. Alas! He did not reflect that they withered in the very gathering. The roses of pleasure seldom last long enough to adorn the brow of him who plucks them; for they are the only roses which do not retain their sweetness after they have lost their beauty.

The heathen poets often pressed on their readers the necessity of considering the shortness of life as an incentive to pleasure and voluptuousness, lest the season for indulging in them should pass unimproved. The dark and uncertain notions, not to say the absolute disbelief, which they entertained of a future state, is the only apology that can be offered for this reasoning. But, while we censure their tenets, let us not adopt their errors; errors which would be infinitely more inexcusable in us, who, from the clearer views which revelation has given us, shall not have their ignorance or their doubts to plead. It were well if we availed ourselves of that portion of their precept, which inculcates the improvement of every moment of our time; but not, like them, to dedicate the moments so redeemed to the pursuit of sensual and perishable pleasures, but to the securing of those which are spiritual in their nature, and eternal in their duration.

If, indeed, like the miserable beings[3] imagined by Swift, with a view to cure us of the irrational desire after immoderate length of days, we were condemned to a wretched earthly immortality, we should have an excuse for spending some portion of our time in dissipation, as we might then pretend, with some color of reason, that we proposed, at a distant period, to enter on a better course of action. Or, if we never formed any such resolution, it would make no material difference to beings whose state was

already unalterably fixed. But of the scanty portion of days assigned to our lot, not one should be lost in weak and irresolute procrastination.

Those who have not yet determined on the side of vanity, who, like Hercules (before he knew the queen of Lydia, and had learnt to spin), have not resolved on their choice between virtue and pleasure, may reflect, that it is still in their power to imitate that hero in his noble choice, and in his virtuous rejection. They may also reflect, with grateful triumph, that Christianity furnishes them with a better guide than the tutor of Alcides, and with a surer light than the doctrines of pagan philosophy.

It is far from my design severely to condemn the innocent pleasures of life: I would only beg leave to observe, that those which are criminal should never be allowed; and that even the most innocent will, by immoderate use, soon cease to be so.

The women of this country were not sent into the world to shun society, but to embellish it; they were not designed for wilds and solitudes, but for the amiable and endearing offices of social life. They have useful stations to fill, and important characters to sustain. They are of a religion which does not impose penances, but enjoins duties ; a religion of perfect purity, but of perfect benevolence also; a religion which does not condemn its followers to indolent seclusion from the world, but assigns them the more dangerous, though more honorable province, of living uncorrupted in it; in fine, a religion which does not direct them to fly from the multitude, that they may do nothing, but which positively forbids them to follow a multitude to do evil.

Endnotes - Chapter 1

1 The emperor Caligula. VOL. II. 15

2 Nothing can be more admirable than the manner in which this allegory is conducted; and the whole work, not to mention its images, machinery, and other poetical beauties, is written in the very finest strain of morality. In this latter respect, it is evidently superior to the works of the ancients, the moral of which is frequently tainted by the grossness of their mythology. Something of the purity of the Christian religion may be discovered even in Fenelon's heathens, and they catch a tincture of piety in passing through the hands of that amiable prelate.

3 The Struldbrugs. See Voyage to Laputa.

2

Thoughts on Conversation

IT has been advised, and by very respectable authorities too, that in conversation women should carefully conceal any knowledge or learning they may happen to possess. I own, with submission, that I do not see either the necessity or propriety of this advice. For if a young lady has that discretion and modesty, without which all knowledge is little worth, she will never make an ostentatious parade of it, because she will rather be intent on acquiring more, than on displaying what she has.

I am at a loss to know why a young female is instructed to exhibit, in the most advantageous point of view, her skill in music, her singing, dancing, taste in dress, and her acquaintance with the most fashionable games and amusements, while her piety is to be anxiously concealed, and her knowledge affectedly disavowed, lest the former should draw on her the appellation of an enthusiast, or the latter that of a pedant.

In regard to knowledge, why should she forever affect to be

on her guard lest she should be found guilty of a small portion of it? She need be the less solicitous about it, as it seldom proves to be so very considerable as to excite astonishment or admiration; for, after all the acquisitions which her talents and her studies have enabled her to make, she will, generally speaking, be found to have less of what is called learning than a common schoolboy.

It would be to the last degree presumptuous and absurd, for a young woman to pretend to give the *ton* to the company; to interrupt the pleasure of others, and her own opportunity of improvement, by talking when she ought to listen; or to introduce subjects out of the common road, in order to show her own wit, or expose the want of it in others: but were the sex to be totally silent when any topic of literature happens to be discussed in their presence, conversation would lose much of its vivacity, and society would be robbed of one of its most interesting charms.

How easily and effectually may a well-bred woman promote the most useful and elegant conversation, almost without speaking a word! For the modes of speech are scarcely more variable than the modes of silence. The silence of listless ignorance, and the silence of sparkling intelligence, are perhaps as separately marked, and as distinctly expressed, as the same feelings could have been by the most equivocal language. A woman, in a company where she has the least influence, may promote any subject by a profound and invariable attention, which shows that she is pleased with it, and by an illuminated countenance, which proves she understands it. This obliging attention is the most flattering encouragement in the world to men of sense and letters, to continue any topic of instruction or entertainment they happen to be engaged in: it owed its introduction perhaps to accident, – the best introduction in the world for a subject of ingenuity, – which,

though it could not have been formally proposed without pedantry, may be continued with ease and good humor; but which will be frequently and effectually stopped by the listlessness, inattention, or whispering of silly girls, whose weariness betrays their ignorance, and whose impatience exposes their ill-breeding. A polite man, however deeply interested in the subject on which he is conversing, catches at the slightest hint to have done: a look is a sufficient intimation; and if a pretty simpleton, who sits near him, seems *distraite*, he puts an end to his remarks, to the great regret of the reasonable part of the company, who, perhaps, might have gained more improvement by the continuance of such a conversation, than a week's reading would have yielded them; for it is such company as this, that give an edge to each other's wit, "as iron sharpeneth iron."

That silence is one of the great arts of conversation is allowed by Cicero himself, who says, there is not only an art, but even an eloquence in it. And this opinion is confirmed by a great modern, [1]in the following little anecdote from one of the ancients.

When many Grecian philosophers had a solemn meeting before the ambassador of a foreign prince, each endeavored to show his parts by the brilliancy of his conversation, that the ambassador might have something to relate of the Grecian wisdom. One of them, offended, no doubt, at the loquacity of his companions, observed a profound silence; when the ambassador, turning to him, asked, "But what have you to say, that I may report it?" He made this laconic, but very pointed reply: "Tell your king, that you have found one among the Greeks who knew how to be silent."

There is a quality infinitely more intoxicating to the female mind than knowledge – this is, wit, the most captivating, but the

most dreaded of all talents; the most dangerous to those who have it, and the most feared by those who have it not. Though it is against all the rules, yet I cannot find in my heart to abuse this charming quality. He who is grown rich without it, in safe and sober dulness, shuns it as a disease, and looks upon poverty as its invariable concomitant. The moralist declaims against it, as the source of irregularity; and the frugal citizen dreads it more than bankruptcy itself for he considers it as the parent of extravagance and beggary. –The Cynic will ask of what use it is. Of very little, perhaps: no more is a flower-garden, and yet it is allowed as an object of innocent amusement and delightful recreation. A woman, who possesses this quality, has received a most dangerous present, perhaps not less so than beauty itself; especially if it be not sheathed in a temper peculiarly inoffensive, chastised by a most correct judgment, and restrained by more prudence than falls to the common lot.

This talent is more likely to make a woman vain than knowledge; for as wit is the immediate property of its possessor, and learning is only an acquaintance with the knowledge of other people, there is much more danger that we should be vain of what is our own, than of what we borrow.

But wit, like learning, is not near so common a thing as is imagined. Let not, therefore, a young lady be alarmed at the acuteness of her own wit, any more than at the abundance of her own knowledge. The great danger is, lest she should mistake pertness, flippancy, or imprudence, for this brilliant quality, or imagine she is witty, only because she is indiscreet. This is very frequently the case; and this makes the name of wit so cheap, while its real existence is so rare.

Lest the flattery of her acquaintance, or an overweening

opinion of her own qualifications, should lead some vain and petulant girl into a false notion that she has a great deal of wit, when she has only a redundancy of animal spirits, she may not find it useless to attend to the definition of this quality, by one who had as large a portion of it as most individuals could ever boast: –

> 'Tis not a tale, 'tis not a jest,
> Admired with laughter at a feast,
> Nor florid talk, which can that title gain;
> The proofs of wit forever must remain.
>
> Neither can that have any place,
> At which a virgin hides her face;
> Such dross the fire must purge away; 'tis just
> The author blush there, where the reader must.
> COWLEY

But those who actually possess this rare talent, cannot be too abstinent in the use of it. It often makes admirers, but it never makes friends; I mean, where it is the predominant feature; and the unprotected and defenceless state of womanhood calls for friendship more than for admiration. She who does not desire friends has a sordid and insensible soul; but she who is ambitious of making every man her admirer, has an invincible vanity and a cold heart.

But to dwell only on the side of policy, a prudent woman, who has established the reputation of some genius, will sufficiently maintain it, without keeping her faculties always on the stretch to say *good things*. Nay, if reputation alone be her object,

she will gain a more solid one by her forbearance, as the wiser part of her acquaintance will ascribe it to the right motive, which is, not that she has less wit, but that she has more judgment.

The fatal fondness for indulging a spirit of ridicule, and the injurious and irreparable consequences which sometimes attend the *too prompt reply*, can never be too seriously or too severely condemned. Not to offend is the first step towards pleasing. To give pain is as much an offence against humanity, as against good breeding; and surely it is as well to abstain from an action because it is sinful, as because it is unpolite. In company, young ladies would do well, before they speak, to reflect, if what they are going to say may not distress some worthy person present, by wounding them in their persons, families, connections, or religious opinions. If they find it will touch them in either of these, I should advise them to suspect, that what they were going to say is not so very good a thing as they at first imagined. Nay, if even it was one of those bright ideas, which "Venus has imbued with a fifth part of her nectar," so much greater will be their merit in suppressing it, if there was a probability it might offend. Indeed, if they have the temper and prudence to make such a previous reflection, they will be more richly rewarded by their own inward triumph, at having suppressed a lively but severe remark, than they could have been with the dissembled applauses of the whole company, who, with that complaisant deceit which good breeding too much authorizes, affect openly to admire what they secretly resolve never to forgive.

I have always been delighted with the story of the little girl's eloquence, in one of the Children's Tales, who received from a friendly fairy the gift, that at every word she uttered, pinks, roses, diamonds, and pearls should drop from her mouth. The

hidden moral appears to be this, that it was the sweetness of her temper which produced this pretty fanciful effect; for when her malicious sister desired the same gift from the good-natured, tiny intelligence, the venom of her own heart converted it into poisonous and loathsome reptiles.

A man of sense and breeding will sometimes join in the laugh, which has been raised at his expense, by an ill-natured repartee; but if it was very cutting, and one of those shocking sort of truths, which, as they can scarcely be pardoned even in private, ought never to be uttered in public, he does not laugh because he is pleased, but because he wishes to conceal how much he is hurt. As the sarcasm was uttered by a lady, so far from seeming to resent it, he will be the first to commend it; but notwithstanding that, he will remember it as a trait of malice, when the whole company shall have forgotten it as a stroke of wit. Women are so far from being privileged by their sex to say unhandsome or cruel things, that it is this very circumstance which renders them more intolerable. When the arrow is lodged in the heart, it is no relief to him who is wounded to reflect, that the hand which shot it was a fair one.

Many women, when they have a favorite point to gain, or an earnest wish to bring any one over to their opinion, often use a very disingenuous method: they will state a case ambiguously, and then avail themselves of it in whatever manner shall best answer their purpose ; leaving your mind in a state of indecision as to their real meaning, while they triumph in the perplexity they have given you by the unfair conclusions they draw, from premises equivocally stated. They will also frequently argue from exceptions instead of rules, and are astonished when you are not willing to be contented with a prejudice, instead of a reason.

In a sensible company of both sexes, where women are not restrained by any other reserve than what their natural modesty imposes, and where the intimacy of all parties authorizes the utmost freedom of communication, should any one inquire what were the general sentiments on some particular subject, it will, I believe, commonly happen, that the ladies, whose imaginations have kept pace with the narration, have anticipated its end, and are ready to deliver their sentiments on it as soon as it is finished. While some of the male hearers, whose minds were busied in settling the propriety, comparing the circumstances, and examining the consistences of what was said, are obliged to pause and discriminate, before they think of answering. Nothing is so embarrassing as a variety of matter; and the conversation of women is often more perspicuous, because it is less labored.

A man of deep reflection, if he does not keep up an intimate commerce with the world, will be sometimes so entangled in the intricacies of intense thought, that he will have the appearance of a confused and perplexed expression; while a sprightly woman will extricate herself with that lively and "rash dexterity," which will almost always please, though it is very far from being always right. It is easier to confound than to convince an opponent; the former may be effected by a turn that has more happiness than truth in it. Many an excellent reasoner, well skilled in the theory of the schools, has felt himself discomfited by a reply, which, though as wide of the mark and as foreign to the question as can be conceived, has disconcerted him more than the most startling proposition, or the most accurate chain of reasoning, could have done; and he has borne the laugh of his fair antagonist, as well as of the whole company, though he could not but feel that his own argument was attended with the fullest demonstration : so

true is it, that it is not always necessary to be right, in order to be applauded.

But let not a young lady's vanity be too much elated with this false applause, which is given, not to her merit, but to her sex: she has not, perhaps, gained a victory, though she may be allowed a triumph; and it should humble her to reflect, that the tribute is paid, not to her strength, but her weakness. It is worth while to discriminate between that applause which is given from the complaisance of others, and that which is paid to our own merit.

Where great sprightliness is the natural bent of the temper, girls should endeavor to habituate themselves to a custom of observing, thinking, and reasoning. I do not mean, that they should devote themselves to abstruse speculation, or the study of logic; but she who is accustomed to give a due arrangement to her thoughts, to reason justly and pertinently on common affairs, and judiciously to deduce effects from their causes, will be a better logician than some of those who claim the name, because they have studied the art: this is being "learned without the rules;" the best definition, perhaps, of that sort of literature which is properest for the sex.

That species of knowledge, which appears to be the result of reflection rather than of science, sits peculiarly well on women. It is not uncommon to find a lady, who, though she does not know a rule of syntax, scarcely ever violates one; and who constructs every sentence she utters, with more propriety than many a learned dunce, who has every rule of Aristotle by heart, and who can lace his own threadbare discourse with the golden shreds of Cicero and Virgil.

It has been objected, and I fear with some reason, that female conversation is too frequently tinctured with a censorious spirit,

and that ladies are seldom apt to discover much tenderness for the errors of a fallen sister.

If it be so, it is a grievous fault.

No arguments can justify, no pleas can extenuate it. To insult over the miseries of an unhappy creature, is inhuman; not to compassionate them is unchristian. The worthy part of the sex always express themselves humanely on the failings of others, in proportion to their own undeviating goodness.

And here I cannot help remarking that young women do not always carefully distinguish between running into the error of detraction, and its opposite extreme of indiscriminate applause. This proceeds from the false idea they entertain that the direct contrary to what is wrong must be right. Thus the dread of being only suspected of one fault makes them actually guilty of another. The desire of avoiding the imputation of envy, impels them to be insincere; and to establish a reputation for sweetness of temper and generosity, they affect sometimes to speak of very indifferent characters with the most extravagant applause. With such, the hyperbole is a favorite figure; and every degree of comparison but the superlative, is rejected, as cold and inexpressive. But this habit of exaggeration greatly weakens their credit, and destroys the weight of their opinion on other occasions; for people very soon discover what degree of faith is to be given both to their judgment and veracity. And those of real merit will no more be flattered by that approbation, which cannot distinguish the value of what it praises, than the celebrated painter must have been at the judgment passed on his works by an ignorant spectator, who, being asked what he thought of such and such very capital but

very different pieces, cried out, in an affected rapture, "All alike! All alike!"

It has been proposed to the young, as a maxim of supreme wisdom, to manage so dexterously in conversation, as to appear to be well acquainted with subjects of which they are totally ignorant; and this, by affecting silence in regard to those on which they are known to excel. But why counsel this disingenuous fraud? Why add to the numberless arts of deceit, this practice of deceiving, as it were, on a settled principle? If to disavow the knowledge they really have, be a culpable affectation, then, certainly, to insinuate an idea of their skill, where they are actually ignorant, is a most unworthy artifice.

But out of all the qualifications for conversation, humility, if not the most brilliant, is the safest, the most amiable, and the most feminine. The affectation of introducing subjects with which others are unacquainted, and of displaying talents superior to the rest of the company, is as dangerous as it is most foolish.

There are many, who never can forgive another for being more agreeable and more accomplished than themselves, and who can pardon any offence rather than an eclipsing merit. Had the nightingale in the fable conquered his vanity, and resisted the temptation of showing a fine voice, he might have escaped the talons of the hawk. The melody of his singing was the cause of his destruction; his merit brought him into danger, and his vanity cost him his life.[2]

Endnotes – Chapter 2

1 Lord Bacon.

2 The poetical fable here alluded to is in Strada's Prolusions on the Style of Claudian, and has been translated into English verse by different writers; particularly Ford, the dramatist, and by Dr. Gibbons, as an example of the Enantiosis in his "Treatise on Rhetoric," published in 1767 – ED.

3

On Envy

Envy came next, Envy with squinting eyes,
Sick of a strange disease, his neighbor's health;
Best then he lives when any better dies,
Is never poor but in another's wealth:
 On best men's harms and griefs he feeds his fill,
 Else his own maw doth eat with spiteful will:
Ill must the temper be, where diet is so ill.
 FLETCHER'S PURPLE ISLAND

"ENVY (says Lord Bacon) has no holidays." There cannot, perhaps, be a more lively and striking description of the miserable state of mind those endure, who are tormented with this vice. A spirit of emulation has been supposed to be the source of the greatest improvements; and there is no doubt but the warmest rivalship will produce the most excellent effects; but it is to be feared, that a perpetual state of contest will injure the temper so

essentially, that the mischief will hardly be counterbalanced by any other advantages. Those, whose progress is the most rapid, will be apt to despise their less successful competitors, who, in return, will feel the bitterest resentment against their more fortunate rivals. Among persons of real goodness, this jealousy and contempt can never be equally felt, because every advancement in piety will be attended with a proportionable increase of humility, which will lead them to contemplate their own improvements with modesty, and to view with charity the miscarriages of others.

When an envious man is melancholy, one may ask him, in the words of Bion, what evil has befallen himself, or what good has happened to another. This last is the scale by which he principally measures his felicity, and the very smilies of his friends are so many deductions from his own happiness. The wants of others are the standard by which he rates his own wealth; and he estimates his riches, not so much by his own possessions, as by the necessities of his neighbors.

When the malevolent intend to strike a very deep and dangerous stroke of malice, they generally begin the most remotely in the world from the subject nearest their hearts. They set out with commending the object of their envy for some trifling quality or advantage, which it is scarcely worth while to possess; they next proceed to make a general profession of their own good-will and regard for him; thus artfully removing any suspicion of their design, and clearing all obstructions for the insidious stab they are about to give; for who will suspect them of an intention to injure the object of their peculiar and professed esteem? The hearer's belief of the fact grows in proportion to the seeming reluctance with which it is told, and to the conviction he has, that the relator is not influenced by any private pique or personal resentment,

but that the confession is extorted from him sorely against his inclination, and purely on account of his zeal for truth.

Anger is less reasonable and more sincere than envy. – Anger breaks out abruptly; envy is a great prefacer; – anger wishes to be understood at once; envy is fond of remote hints and ambiguities; but, obscure as its oracles are, it never ceases to deliver them till they are perfectly comprehended; – anger repeats the same circumstances over again; envy invents new ones at every fresh recital – anger gives a broken, vehement, and interrupted narrative; envy tells a more consistent and more probable, though a falser tale – anger is excessively imprudent, for it is impatient to disclose every thing it knows; envy is discreet, for it has a great deal to hide – anger never consults times or seasons; envy waits for the lucky moment, when the wound it meditates may be made the most exquisitely painful, and the most incurably deep – anger uses more invective; envy does more mischief – simple anger soon runs itself out of breath, and is exhausted at the end of its tale; but it is for that chosen period that envy has treasured up the most barbed arrow in its whole quiver – anger puts a man out of himself; but the truly malicious generally preserve the appearance of self-possession, or they could not so effectually injure. The angry man sets out by destroying his whole credit with you at once, for he very frankly confesses his abhorrence and detestation of the object of his abuse; while the envious man carefully suppresses all his own share in the affair. The angry man defeats the end of his resentment, by keeping *himself* continually before your eyes, instead of his enemy; while the envious man artfully brings forward the object of his malice, and keeps himself out of sight. The angry man talks loudly of his own wrongs; the envious of his adversary's injustice. A passionate person, if his

resentments are not complicated with malice, divides his time between sinning and sorrowing; and, as the irascible passions cannot constantly be at work, his heart may sometimes get a holiday. Anger is a violent act, envy a constant habit – no one can be always angry, but he may be always envious: – an angry man's enmity (if he be generous) will subside when the object of his resentment becomes unfortunate; but the envious man can extract food for his malice out of calamity itself, if he finds his adversary bears it with dignity, or is pitied or assisted in it. The rage of the passionate man is totally extinguished by the death of his enemy; but the hatred of the malicious is not buried even in the grave of his rival: he will envy the good name he has left behind him; he will envy him the tears of his widow, the prosperity of his children, the esteem of his friends, the praises of his epitaph – nay, the very magnificence of his funeral.

"The ear of jealousy heareth all things" (says the wise man); frequently, I believe, more than is uttered, which makes the company of persons infected with it still more dangerous.

When you tell those of a malicious turn any circumstance that has happened to another, though they perfectly know of whom you are speaking, they often affect to be at a loss, to forget his name, or to misapprehend you in some respect or other; and this merely to have an opportunity of slyly gratifying their malice by mentioning some unhappy defect or personal infirmity he labors under; and not contented "to tack his every error to his name," they will, by way of further explanation, have recourse to the faults of his father, or the misfortunes of his family; and this with all the seeming simplicity and candor in the world, merely for the sake of preventing mistakes, and to clear up every doubt of his identity. If you are speaking of a lady, for instance,

they will perhaps embellish their inquiries, by asking if you mean her whose great grandfather was a bankrupt, though she has the vanity to keep a chariot, while others who are much better born walk on foot; or they will afterwards recollect, that you may possibly mean her cousin, of the same name, whose mother was suspected of such or such an indiscretion, though the daughter had the luck to make her fortune by marrying, while her betters are overlooked.

To *hint* at a fault, does more mischief than speaking out: for whatever is left for the imagination to finish, will not fail to be overdone; every hiatus will be more than filled up, and every pause more than supplied. There is less malice, and less mischief too, in telling a man's name than the initials of it; as a worthier person may be involved in the most disgraceful suspicions by such a dangerous ambiguity.

It is not uncommon for the envious, after having attempted to deface the fairest character so industriously, that they are afraid you will begin to detect their malice, to endeavor to remove your suspicions effectually, by assuring you, that what they have just related is only the popular opinion; they themselves can never believe things are so bad as they are said to be; for their part, it is a rule with them always to hope the best; it is their way never to believe or report ill of any one. They will, however, mention the story in all companies, that they may do their friend the service of protesting their disbelief of it. More reputations are thus hinted away by false friends, than are openly destroyed by public enemies. An *if*, or a *but*, or a mortified look, or a languid defence, or an ambiguous shake of the head, or a hasty word affectedly recalled, will demolish a character more effectually than the whole artillery of malice when openly levelled against it.

It is not that envy never praises – No; that would be making a public profession of itself, and advertising its own malignity; whereas the greatest success of its efforts depends on the concealment of their end. When envy intends to strike a stroke of Machiavelian policy, it sometimes affects the language of the most exaggerated applause; though it generally takes care, that the subject of its panegyric shall be a very indifferent and common character, so that it is well aware none of its praises will stick

It is the unhappy nature of envy not to be contented with positive misery, but to be continually aggravating its own torments, by comparing them with the felicities of others. The eyes of envy are perpetually fixed on the object which disturbs it, nor can it avert them from it, though to procure itself the relief of a temporary forgetfulness. On seeing the innocence of the first pair,

> Aside the devil turned,
> For Envy, yet, with jealous leer malign,
> Eyed them askance.

As this enormous sin chiefly instigated the revolt, and brought on the ruin of the angelic spirits, so it is not improbable, that it will be a principal instrument of misery in a future world, for the envious to compare their desperate condition with the happiness of the children of God; and to heighten their actual wretchedness by reflecting on what they have lost.

Perhaps envy, like lying and ingratitude, is practised with more frequency, because it is practised with impunity; but there being no human laws against these crimes, is so far from an inducement to commit them, that this very consideration would be

sufficient to deter the wise and good, if all others were ineffectual; for of how heinous a nature must those sins be, which are judged above the reach of human punishment, and are reserved for the final justice of God himself!

4

On The Danger of Sentimental or Romantic Connections

AMONG the many evils which prevail under the sun, the abuse of words is not the least considerable. By the influence of time, and the perversion of fashion, the plainest and most unequivocal may be so altered, as to have a meaning assigned them almost diametrically opposite to their original signification.

The present age may be termed, by way of distinction, the age of sentiment; a word which, in the implication it now bears, was unknown to our plain ancestors. Sentiment is the varnish of virtue, to conceal the deformity of vice; and it is not uncommon for the same persons to make a jest of religion, to break through the most solemn ties and engagements, to practise every art of latent fraud and open seduction, and yet to value themselves on speaking and writing *sentimentally*.

But this refined jargon, which has infested letters and tainted morals, is chiefly admired and adopted by young ladies of a certain turn, who read *sentimental* books, write *sentimental* letters,

and contract *sentimental* friendships.

Error is never likely to do so much mischief as when it disguises its real tendency, and puts on an engaging and attractive appearance. Many a young woman, who would be shocked at the imputation of an intrigue, is extremely flattered at the idea of a sentimental connection, though, perhaps, with a dangerous and designing man, who, by putting on this mask of plausibility and virtue, disarms her of her prudence, lays her apprehensions asleep, and involves her in misery; misery the more inevitable because unsuspected. For she who apprehends no danger, will not think it necessary to be always upon her guard; but will rather invite than avoid the ruin which comes under so specious and so fair a form.

Such an engagement will be infinitely dearer to her vanity than an avowed and authorized attachment; for one of these sentimental lovers will not scruple, very seriously, to assure a credulous girl, that her unparalleled merit entitles her to the adoration of the whole world, and that the universal homage of mankind is nothing more than the unavoidable tribute extorted by her charms. No wonder, then, she should be easily prevailed on to believe, that an individual is captivated by perfections which might enslave a million. But she should remember, that he who endeavors to intoxicate her with adulation, intends one day most effectually to humble her. For an artful man has always a secret design to pay himself in future for every present sacrifice. And this prodigality of praise, which he now appears to lavish with such thoughtless profusion, is, in fact, a sum economically laid out to supply his future necessities: of this sum he keeps an exact estimate, and at some distant day promises himself the most exorbitant interest for it. If he has address and conduct, and the object of his pursuit much vanity and some sensibility, he seldom

fails of success; for so powerful will be his ascendency over her mind, that she will soon adopt his notions and opinions. Indeed, it is more than probable she possessed most of them before, having gradually acquired them in her initiation into the sentimental character. To maintain that character with dignity and propriety, it is necessary that she should entertain the most elevated ideas of disproportionate alliances and disinterested love; and consider fortune, rank, and reputation as mere chimerical distinctions and vulgar prejudices.

The lover, deeply versed in all the obliquities of fraud, and skilled to wind himself into every avenue of the heart which indiscretion has left unguarded, soon discovers on which side it is most accessible. He avails himself of this weakness by addressing her in a language exactly consonant to her own ideas. He attacks her with her own weapons, and opposes rhapsody to sentiment. He professes so sovereign a contempt for the paltry concerns of money, that she thinks it her duty to reward him for so generous a renunciation. Every plea he artfully advances of his own unworthiness, is considered by her as a fresh demand which her gratitude must answer; and she makes it a point of honor to sacrifice to him that fortune which he is too noble to regard. These professions of humility are the common artifice of the vain, and these protestations of generosity the refuge of the rapacious. And among its many smooth mischiefs, it is one of the sure and successful frauds of sentiment, to affect the most frigid indifference to those external and pecuniary advantages, which it is its great and real object to obtain.

A sentimental girl very rarely entertains any doubt of her personal beauty; for she has been daily accustomed to contemplate it herself, and to hear of it from others. She will not, therefore,

be very solicitous for the confirmation of a truth so self-evident; but she suspects that her pretensions to understanding are more likely to be disputed, and, for that reason, greedily devours every compliment offered to those perfections which are less obvious and more refined. She is persuaded, that men need only open their eyes to decide on her beauty, while it will be the most convincing proof of the taste, sense, and elegance of her admirer, that he can discern and flatter those qualities in her. A man of the character here supposed, will easily insinuate himself into her affections, by means of this latent but leading foible, which may be called the guiding clew to a sentimental heart. He will affect to overlook that beauty which attracts common eyes and ensnares common hearts, while he will bestow the most delicate praises on the beauties of her mind, and finish the climax of adulation by hinting that she is superior to it.

> And when he tells her she hates flattery,
> She says she does, being then most flattered.

But nothing, in general, can end less delightfully than these sublime attachments, even where no acts of seduction were ever practised, but they are suffered, like mere sublunary connections, to terminate in the vulgar catastrophe marriage. That wealth, which lately seemed to be looked on with ineffable contempt by the lover, now appears to be the principal attraction in the eyes of the husband; and he who, but a few short weeks before, in a transport of sentimental generosity, wished her to have been a village maid, with no portion but her crook and her beauty, and that they might spend their days in pastoral love and innocence, has now lost all relish for the Arcadian life, or any other life in

which she must be his companion.

On the other hand, she who was lately

An angel called, and angel-like adored,

is shocked to find herself at once stripped of all her celestial attributes. This late divinity, who scarcely yielded to her sisters of the sky, now finds herself of less importance in the esteem of the man she has chosen, than any other mere mortal woman. No longer is she gratified with the tear of counterfeited passion, the sigh of dissembled rapture, or the language of premeditated adoration. No longer is the altar of her vanity loaded with the oblations of fictitious fondles, the incense of falsehood, or the sacrifice of flattery. Her apotheosis is ended! She feels herself degraded from the dignities and privileges of a goddess, to all the imperfections, vanities, and weaknesses of a slighted woman and a neglected wife. Her faults, which were so lately overlooked, or mistaken for virtues, are now, as Cassius says, set in a notebook. The passion, which was vowed eternal, lasted only a few short weeks; and the indifference, which was so far from being included in the bargain, that it was not so much as suspected, follows them through the whole tiresome journey of their insipid, vacant, joyless existence.

Thus much for the *completion* of the sentimental history. If we trace it back to its beginning, we shall find that a damsel of this cast had her head originally turned by pernicious reading, and her insanity confirmed by imprudent friendships. She never fails to select a beloved *confidante* of her own turn and humor, though, if she can help it, not quite so handsome as herself. A violent intimacy ensues, or, to speak the language of sentiment,

an intimate union of souls immediately takes place, which is wrought to the highest pitch by a secret and voluminous correspondence, though they live in the same street, or perhaps in the same house. This is the fuel which principally feeds and supplies the dangerous flame of sentiment. In this correspondence the two friends encourage each other in the falsest notions imaginable. They represent romantic love as the great important business of human life, and describe all the other concerns of it as too low and paltry to merit the attention of such elevated beings, and fit only to employ the daughters of the plodding vulgar. In these letters, family affairs are misrepresented, family secrets divulged, and family misfortunes aggravated. They are filled with vows of eternal amity, and protestations of never-ending love. But interjections and quotations are the principal embellishments of these very sublime epistles. Every panegyric contained in them is extravagant and hyperbolical, and every censure exaggerated and excessive. In a favorite, every frailty is heightened into a perfection, and in a foe degraded into a crime. The dramatic poets, especially the most tender and romantic, are quoted in almost every line, and every pompous or pathetic thought is forced to give up its natural and obvious meaning, and, with all the violence of misapplication, is compelled to suit some circumstance of imaginary wo of the fair transcriber. Alicia is not too mad for her heroics, nor Monimia too mild for her soft emotions.

Fathers have *flinty* hearts, is an expression worth an empire, and is always used with peculiar emphasis and enthusiasm. For a favorite topic of these epistles is the grovelling spirit and sordid temper of the parents, who will be sure to find no quarter at the hands of their daughters, should they presume to be so unreasonable as to direct their course of reading, interfere in their choice

of friends, or interrupt their very important correspondence. But as these young ladies are fertile in expedients, and as their genius is never more agreeably exercised than in finding resources, they are not without their secret exultation, in case either of the above interesting events should happen, as they carry with them a certain air of tyranny and persecution which is very delightful. For a prohibited correspondence is one of the great incidents of a sentimental life, and a letter clandestinely received, the supreme felicity of a sentimental lady.

Nothing can equal the astonishment of these soaring spirits, when their plain friends or prudent relations presume to remonstrate with them on any impropriety in their conduct. But if these worthy people happen to be somewhat advanced in life, their contempt is then a little softened by pity, at the reflection that such very antiquated poor creatures should pretend to judge what is fit or unfit for ladies of their great refinement, sense, and reading. They consider them as wretches utterly ignorant of the sublime pleasures of a delicate and exalted passion, as tyrants whose authority is to be contemned, and as spies whose vigilance is to be eluded. The prudence of these worthy friends, they term suspicion; and their experience, dotage. For they are persuaded, that the face of things has so totally changed since their parents were young, that though they might then judge tolerably for themselves, yet they are now (with all their advantages of knowledge and observation) by no means qualified to direct their more enlightened daughters; who, if they have made a great progress in the sentimental walk, will no more be influenced by the advice of their mother, than they would go abroad in her laced pinner or her brocade suit.

But young people never show their folly and ignorance more

conspicuously than by this over-confidence in their own judg-ment, and this haughty disdain of the opinion of those who have known more days. Youth has a quickness of apprehension, which it is very apt to mistake for an acuteness of penetration. But youth, like cunning, though very conceited, is very short-sighted, and never more so than when it disregards the instructions of the wise, and the admonitions of the aged. The same vices and follies influenced the human heart in their day, which influence it now, and nearly in the same manner. One who well knew the world and its various vanities, has said, "The thing which hath been, it is that which shall be; and that which is done, is that which shall be done; and there is no new thing under the sun."

It is also a part of the sentimental character, to imagine that none but the young and beautiful have any right to the pleasures of society, or even to the common benefits and blessings of life. Ladies of this turn also affect the most lofty disregard for useful qualities and domestic virtues; and this is a natural consequence; for, as this sort of sentiment is only a weed of idleness, she who is constantly and usefully employed has neither leisure nor pro-pensity to cultivate it.

A sentimental lady principally values herself on the enlarge-ment of her notions, and her liberal way of thinking. This supe-riority of soul chiefly manifests itself in the contempt of those minute delicacies and little decorums, which, trifling as they may be thought, tend at once to dignify the character, and to restrain the levity, of the younger part of the sex.

Perhaps the error here complained of, originates in mistaking *sentiment* and *principle* for each other. Now, I conceive them to be extremely different. Sentiment is the virtue of *ideas*, and principle the virtue of *action*. Sentiment has its seat in the head; princi-

ple in the heart. Sentiment suggests fine harangues and subtle distinctions; principle conceives just notions, and performs good actions in consequence of them. Sentiment refines away the simplicity of truth and the plainness of piety; and, as a celebrated wit[1] has remarked of his no less celebrated contemporary, gives us virtue in words and vice in deeds. Sentiment may be called the Athenian, who *knew* what was right; and principle the Lacedemonian, who *practised* it.

But these qualities will be better exemplified by an attentive consideration of two admirably drawn characters of Milton, which are beautifully, delicately, and distinctly marked. These are, Belial, who may not be improperly called the *Demon of Sentiment*; and Abdiel, who may be termed the *Angel of Principle*.

Survey the picture of Belial, drawn by the sublimest hand that ever held the poetic pencil.

> A fairer person lost not heaven; he seemed
> For dignity composed, and high exploit;
> But all was false and hollow, though his tongue
> Dropped manna, and could make the worse appear
> The better reason, to perplex and dash
> Maturest counsels, for his thoughts were low,
> To vice industrious, but to nobler deeds
> Timorous and slothful; yet he pleased the ear.
>
> *Paradise Lost*, Book II.

Here is a lively and exquisite representation of art, subtlety, wit, fine breeding, and polished manners; on the whole, of a very accomplished and sentimental spirit.

Now turn to the artless, upright, and unsophisticated Abdiel,

> Faithful found
> Among the faithless, faithful only he
> Among innumerable false, unmoved,
> Unshaken, unseduced, unterrified; ..
> His loyalty he kept, his love, his zeal.
> Nor number nor example with him wrought
> To swerve from truth, or change his constant mind,
> Though single. Book V.

But it is not from these descriptions, just and striking as they are, that their characters are so perfectly known, as from an examination of their conduct through the remainder of this divine work; in which it is well worth while to remark the consonancy of their actions, and what the above pictures seem to promise. It will also be observed, that the contrast between them is kept up throughout, with the utmost exactness of delineation, and the most animated strength of coloring.

On a review it will be found, that Belial *talked* all, and Abdiel *did* all. The former,

> With words still clothed in reason's guise,
> Counselled ignoble ease, and peaceful sloth,
> Not peace. Book II.

In Abdiel, you will constantly find the eloquence of action. When tempted by the rebellious angels, with what retorted scorn, with what honest indignation he deserts their multitudes, and retreats from their contagious society!

All night the dreadless angel unpursued
Through heaven's wide champaign held his way.

Book VI.

No wonder he was received with such acclamations of joy by the celestial powers, when there was –

But one,
Yes, of so many myriads fallen, but one
Returned not lost.

Ibid.

And afterwards, in a close contest with the arch fiend,

A noble stroke he lifted high
On the proud crest of Satan.

Ibid.

What was the effect of this courage of the vigilant and active seraph?

Amazement seized
The rebel throne, but greater rage to see
Thus foiled their mightiest.

Abdiel had the superiority of Belial as much in the warlike combat, as in the peaceful counsels,

Nor was it aught but just,
That he who in debate of truth had won,
Should win in arms, in both disputes alike
Victor.

But, notwithstanding I have spoken with some asperity against sentiment as opposed to principle, yet I am convinced, that true, genuine sentiment (not the sort I have been describing) may be so connected with principle, as to bestow on it its brightest lustre and its most captivating graces. And enthusiasm is so far from being disagreeable, that a portion of it is perhaps indispensably necessary in an engaging woman. But it must be the enthusiasm of the heart, not of the senses. It must be the enthusiasm which grows up with a feeling mind, and is cherished by a virtuous education; not that which is compounded of irregular passions, and artificially refined by books of unnatural fiction and improbable adventure. I will even go so far as to assert, that a young woman cannot have any real greatness of soul, or true elevation of principle, if she has not a tincture of what the vulgar would call romance, but which persons of a certain way of thinking will discern to proceed from those fine feelings, and that charming sensibility, without which, though a woman may be worthy, yet she can never be amiable.

But this dangerous merit cannot be too rigidly watched, as it is very apt to lead those who possess it into inconveniences from which less interesting characters are happily exempt. Young women of strong sensibility may be carried by the very amiableness of this temper into the most alarming extremes. Their tastes are passions. They love and hate with all their hearts, and scarcely suffer themselves to feel a reasonable preference before it strengthens into a violent attachment.

When an innocent girl of this open, trusting, tender heart, happens to meet with one of her own sex and age, whose address and manners are engaging, she is instantly seized with an ardent

desire to commence a friendship with her. She feels the most lively impatience at the restraints of company and the decorums of ceremony. She longs to be alone with her; longs to assure her of the warmth of her tenderness, and generously ascribes to the fair stranger all the good qualities she feels in her own heart; or rather all those which she has met with in her reading, dispersed in a variety of heroines. She is persuaded, that her new friend unites them all in herself, because she carries in her prepossessing countenance the promise of them all. How cruel and how censorious would this inexperienced girl think her mother was, who should venture to hint, that the agreeable unknown had defects in her temper, or exceptions in her character! She would mistake these hints of discretion for the insinuations of an uncharitable disposition. At first, she would, perhaps, listen to them with a generous impatience, and afterwards with a cold and silent disdain. She would despise them as the effect of prejudice, misrepresentation, or ignorance. The more aggravated the censure, the more vehemently would she protest in secret, that her friendship for this dear injured creature (who is raised much higher in her esteem by such injurious suspicions) shall know no bounds, as she is assured it can know no end.

Yet this trusting confidence, this honest indiscretion, is, at this early period of life, as amiable as it is natural; and will, if wisely cultivated, produce, at its proper season, fruits infinitely more valuable than all the guarded circumspection of premature, and therefore artificial, prudence. Men, I believe, are seldom struck with these sudden prepossessions in favor of each other. They are not so unsuspecting, nor so easily led away by the predominance of fancy. They engage more warily, and pass through the several stages of acquaintance, intimacy, and confidence, by slower gra-

dations; but women, if they are sometimes deceived in the choice of a friend, enjoy even then a higher degree of satisfaction than if they never trusted. For to be always clad in the burdensome armor of suspicion is more painful and inconvenient than to run the hazard of suffering now and then a transient injury.

But the above observations only extend to the young and the inexperienced; for I am very certain, that women are capable of as faithful and as durable friendship as any of the other sex. They can enter not only into all the enthusiastic tenderness, but into all the solid fidelity of attachment. And if we cannot oppose instances of equal weight with those of Nysus and Euryalus, Theseus and Pirithous, Pylades and Orestes, let it be remembered, that it is because the recorders of those characters were men, and that the very existence of them is merely poetical.

Endnotes – Chapter 4

1 See Voltaire's Prophecy concerning Rousseau. VOL. II.

5

On True and False Meekness

A LOW voice and soft address are the common indications of a well-bred woman, and should seem to be the natural effects of a meek and quiet spirit; but they are only the outward and visible signs of it; for they are no more meekness itself, than a red coat is courage, or a black one devotion.

Yet nothing is more common than to mistake the sign for the thing itself; nor is any practice more frequent than that of endeavoring to acquire the exterior mark, without once thinking to labor after the interior grace. Surely, this is beginning at the wrong end, like attacking the symptom, and neglecting the disease. To regulate the features while the soul is in tumults, or to command the voice while the passions are without restraint, is as idle as throwing odors into a stream when the source is polluted.

The *sapient* king,[1] who knew better than any man the nature and the power of beauty, has assured us, that the temper of the mind has a strong influence upon the features: "Wisdom maketh

the face to shine," says that exquisite judge; and surely no part of wisdom is more likely to produce this amiable effect, than a placid serenity of soul.

It will not be difficult to distinguish the true from the artificial meekness. The former is universal and habitual; the latter, local and temporary. Every young female may keep this rule by her, to enable her to form a just judgment of her own temper: if she is not as gentle to her chambermaid as she is to her visitor, she may rest satisfied that the spirit of gentleness is not in her.

Who would not be shocked and disappointed to behold a well-bred young lady, soft and engaging as the doves of Venus, displaying a thousand graces and attractions to win the hearts of a large company; and the instant they are gone, to see her look mad as the Pythian maid, and all the frightened graces driven from her furious countenance, only because her gown was brought home a quarter of an hour later than she expected, or her riband sent half a shade lighter or darker than she ordered?

All men's characters are said to proceed from their servants; and this is more particularly true of ladies; for as their situations are more domestic, they lie more open to the inspection of their families, to whom their real characters are easily and perfectly known; for they seldom think it worth while to practise any disguise before those whose good opinion they do not value, and who are obliged to submit to their most insupportable humors, because they are paid for it.

Among women of breeding, the exterior of gentleness is so uniformly assumed, and the whole manner is so perfectly level and *uni*, that it is next to impossible for a stranger to know any thing of their true dispositions by conversing with them, and even the very features are so exactly regulated, that physiognomy,

which may sometimes be trusted among the vulgar, is, with the polite, a most lying science.

A very termagant woman, if she happens also to be a very artful one, will be conscious she has so much to conceal, that the dread of betraying her real temper will make her put on an overacted softness, which, from its very excess, may be distinguished from the natural, by a penetrating eye. That gentleness is ever liable to be suspected for the counterfeited, which is so excessive as to deprive people of the proper use of speech and motion, or which, as Hamlet says, makes them lisp and amble, and nickname God's creatures.

The countenance and manners of some very fashionable persons may be compared to the inscriptions on their monuments, which speak nothing but good of what is within; but he who knows any thing of the world, or of the human heart, will no more trust to the courtesy, than he will depend on the epitaph.

Among the various artifices of factitious meekness, one of the most frequent and most plausible, is that of affecting to be always equally delighted with all persons and all characters. The society of these languid beings is without confidence, their friendship without attachment, and their love without affection, or even preference. This insipid mode of conduct may be safe, but I cannot think it has either taste, sense, or principle in it.

These uniformly smiling and approving ladies, who have neither the noble courage to reprehend vice, nor the generous warmth to bear their honest testimony in the cause of virtue, conclude every one to be ill-natured who has any penetration, and look upon a distinguishing judgment as want of tenderness. But they should learn, that this discernment does not always proceed from an uncharitable temper, but from that long expe-

rience and thorough knowledge of the world, which lead those who have it to scrutinize into the conduct and disposition of men, before they trust entirely to those fair appearances, which sometimes veil the most insidious purposes.

We are perpetually mistaking the qualities and dispositions of our own hearts. We elevate our failings into virtues, and qualify our vices into weaknesses; and hence arise so many false judgments respecting meekness. Self-ignorance is at the root of all this mischief. Many ladies complain that, for their part, their spirit is so meek they can bear nothing; whereas, if they spoke truth, they would say, their spirit is so high and unbroken, that they can bear nothing. Strange! To plead their meekness as a reason why they cannot endure to be crossed, and to produce their impatience of contradiction as a proof of their gentleness!

Meekness, like most other virtues, has certain limits, which it no sooner exceeds than it becomes criminal. Servility of spirit is not gentleness, but weakness, and if allowed, under the specious appearances it sometimes puts on, will lead to the most dangerous compliances. She who hears innocence maligned without vindicating it, falsehood asserted without contradicting it, or religion profaned without resenting it, is not gentle, but wicked.

To give up the cause of an innocent, injured friend, if the popular cry happens to be against him, is the most disgraceful weakness. This was the case of Madame de Maintenon. She loved the character and admired the talents of Racine; she caressed him while he had no enemies, but wanted the greatness of mind, or rather the common justice, to protect him against their resentment when he had; and her favorite was abandoned to the suspicious jealousy of the king, when a prudent remonstrance might have preserved him. – But her tameness, if not absolute

connivance in the great massacre of the Protestants, in whose church she had been bred, is a far more guilty instance of her weakness; an instance which, in spite of all her devotional zeal and incomparable prudence, will disqualify her from shining in the annals of good women, however she may be entitled to figure among the great and the fortunate. Compare her conduct with that of her undaunted and pious countryman and contemporary, Bougi, who, when Louis would have prevailed on him to renounce his religion for a commission or a government, nobly replied, "If I could be persuaded to betray my God for a marshal's staff", I might betray my king for a bride of much less consequence."

Meekness is imperfect, if it be not both active and passive; if it will not enable us to subdue our own passions and resentments, as well as qualify us to bear patiently the passion and resentments of others.

Before we give way to any violent emotion of anger, it would, perhaps, be worth while to consider the object which excites it, and to reflect for a moment, whether the thing we so ardently desire, or so vehemently resent, be really of as much importance to us, as that delightful tranquility of soul, which we renounce in pursuit of it. If, on a fair calculation, we find we are not likely to get as much as we are sure to lose, then, putting all religious considerations out of the question, common sense and human policy will tell us, we have made a foolish and unprofitable exchange. Inward quiet is a part of one's self; the object of our resentment may be only a matter of opinion; and certainly, what makes a portion of our actual happiness ought to be too dear to us to be sacrificed for a trifling, foreign, perhaps imaginary good.

The most pointed satire I remember to have read, on a mind

enslaved by anger, is an observation of Seneca's. "Alexander," said he, "had two friends, Clitus and Lysimachus; the one he exposed to a lion, the other to himself: he who was turned loose to the beast escaped; but Clitus was murdered, for he was turned loose to an angry man."

A passionate woman's happiness is never in her own keeping: it is the sport of accident, and the slave of events. It is in the power of her acquaintance, her servants, but chiefly of her enemies, and all her comforts lie at the mercy of others. So far from being willing to learn of him who was meek and lowly, she considers meekness as the want of a becoming spirit, and lowliness as a despicable and vulgar meanness. And an imperious woman will so little covet the ornament of a meek and quiet spirit, that it is almost the only ornament she will not be solicitous to wear. But resentment is a very expensive vice. How dearly has it cost its votaries, even from the sin of Cain, the first offender in this kind! "It is cheaper (says a pious writer) to forgive, and save the charges."

If it were only for mere human reasons, it would turn to a better account to be patient: nothing defeats the malice of an enemy like a spirit of forbearance; the return of rage for rage cannot be so effectually provoking. True gentleness, like an impenetrable armor, repels the most pointed shafts of malice: they cannot pierce through this invulnerable shield, but either fall hurtless to the ground, or return to wound the hand that shot them.

A meek spirit will not look out of itself for happiness, because it finds a constant banquet at home; yet, by a sort of divine alchemy, it will convert all external events to its own profit, and be able to deduce some good, even from the most unpromising: it will extract comfort and satisfaction from the most barren cir-

cumstances; it will "suck honey out of the rock, and oil out of the flinty rock."

But the supreme excellence of this complacent quality is, that it naturally disposes the mind where it resides to the practice of every other that is amiable. Meekness may be called the pioneer of all the other virtues, which levels every obstruction, and smooths every difficulty that might impede their entrance, or retard their progress.

The peculiar importance and value of this amiable virtue may be further seen in its permanency. Honors and dignities are transient; beauty and riches, frail and fugacious to a proverb. Would not the truly wise, therefore, wish to have some one possession, which they might call their own in the severest exigences? But this wish can only be accomplished by acquiring and maintaining that calm and absolute self-possession, which, as the world had no hand in giving, it cannot, by the most malicious exertion of its power, take away.

Endnotes – Chapter 5

1 Solomon is here understood; but the term by which he is indicated, ill suits the dignity of one who had the reputation of being the wisest of men. -ED.

6

Thoughts on the Cultivation of the Heart and Temper in the Education of Daughters

I HAVE not the foolish presumption to imagine, that I can offer any thing new on a subject which has been so successfully treated by many able and learned writers. I would only, with all possible deference, beg leave to hazard a few short remarks on that part of the subject of education, which I would call the *education of the heart*. I am well aware, that this part also has not been less skillfully and forcibly discussed than the rest, though I cannot, at the same time, help remarking, that it does not appear to have been so much adopted into common practice.

It appears, then, that notwithstanding the great and real improvements which have been made in the affair of female education, and notwithstanding the more enlarged and generous views of it which prevail in the present day, that there is still a very material defect, which it is not, in general, enough the object of attention to remove. This defect seems to consist in this, that too little regard is paid to the dispositions of the mind, that

the indications of the temper are not properly cherished, nor the affections of the heart sufficiently regulated.

In the first education of girls, as far as the customs which fashion establishes are right, they should undoubtedly be followed. Let the exterior be made a considerable object of attention, but let it not be the principal, let it not be the only one. Let the graces be industriously cultivated, but let them not be cultivated at the expense of the virtues. Let the arms, the head, the whole person be carefully polished, but let not the heart be the only portion of the human anatomy which shall be totally overlooked.

The neglect of this cultivation seems to proceed as much from a bad taste, as from a false principle. The generality of people form their judgment of education by slight and sudden appearances, which is certainly a wrong way of determining. Music, dancing, and languages gratify those who teach them, by perceptible and almost immediate effects; and, when there happens to be no imbecility in the pupil, nor deficiency in the master, every superficial observer can, in some measure, judge of the progress. The effects of most of these accomplishments address themselves to the senses; and there are more who can see and hear, than there are who can judge and reflect.

Personal perfection is not only more obvious, it is also more rapid; and, even in very accomplished characters, elegance usually precedes principle.

But the heart, that natural seat of evil propensities, that little, troublesome empire of the passions, is led to what is right by slow motions and imperceptible degrees. It must be admonished by reproof, and allured by kindness. Its liveliest advances are frequently impeded by the obstinacy of prejudice, and its brightest

promises often obscured by the tempests of passion. It is slow in its acquisition of virtue, and reluctant in its approaches to piety.

There is another reason, which proves this mental cultivation to be more important, as well as more difficult, than any other part of education. In the usual fashionable accomplishments, the business of acquiring them is almost always getting forwards, and one difficulty is conquered before another is suffered to show itself; for a prudent teacher will level the road his pupil is to pass, and smooth the inequalities which might retard her progress.

But in morals (which should be the great object constantly kept in view), the task is far more difficult. The unruly and turbulent desires of the heart are not so obedient; one passion will start up before another is suppressed. The subduing Hercules cannot cut off the heads so often as the prolific Hydra can produce them, nor fell the stubborn Antæus so fast as he can recruit his strength, and rise in vigorous and repeated opposition.

If all the accomplishments could be bought at the price of a single virtue, the purchase would be infinitely dear! And, however startling it may sound, I think it is, notwithstanding, true, that the labors of a good and wise mother, who is anxious for her daughter's most important interests, will seem to be at variance with those of her instructers. She will doubtless rejoice at her progress in any polite art, but she will rejoice with trembling – humility and piety form the solid and durable basis, on which she wishes to raise the encouraged very early in life. This immaturity of wit is helped on by frivolous reading, which will produce its effect in much less time than books of solid instruction; for the imagination is touched sooner than the understanding; and effects are more rapid as they are more pernicious. Conversation should be the *result* of education, not the *precursor* of it. It is

a golden fruit, when suffered to grow gradually on the tree of knowledge; but, if precipitated by forced and unnatural means, it will in the end become vapid, in proportion as it is artificial.

The best effects of a careful and religious education are often very remote: they are to be discovered in future scenes, and exhibited in untried connections. Every event of life will be putting the heart into fresh situations, and making demands on its prudence, its firmness, its integrity, or its piety. Those whose business it is to form it, can foresee none of these situations; yet, as far as human wisdom will allow, they must enable it to provide for them all, with an humble dependence on the divine assistance. A well-disciplined soldier must learn and practise all his evolutions, though he does not know on what service his leader may command him, by what foe he shall be attacked, nor what mode of combat the enemy may use.

One great art of education consists in not suffering the feelings to become too acute by unnecessary awakening, nor too obtuse by the want of exertion. The former renders them the source of calamity, and totally ruins the temper; while the latter blunts and debases them, and produces a dull, cold and selfish spirit. For the mind is an instrument, which, if wound too high, will lose its sweetness, and if not enough strained, will abate of its vigor.

How cruel is it to extinguish, by neglect or unkindness, the precious sensibility of an open temper, to chill the amiable glow of an ingenuous soul, and to quench the bright flame of a noble and generous spirit! These are of higher worth than all the documents of learning, of dearer price than all the advantages which can be derived from the most refined and artificial mode of education.

"But sensibility and delicacy, and an ingenuous temper, make

no part of education," exclaims the pedagogue: "they are reducible to no class – they come under no article of instruction – they belong neither to languages nor to music." What an error! They *are* a part of education, and of finitely more value

> Than all their pedant discipline e'er knew.

It is true they are ranged under no class, but they are superior to all; they are of more esteem than languages or music, for they are the language of the heart, and the music of the according passions. Yet this sensibility is, in many instances, so far from being cultivated, that it is not uncommon to see those who affect more than usual sagacity, cast a smile of supercilious pity at any indication of a warm, generous, or enthusiastic temper in the lively and the young; as much as to say, "They will know better, and will have more discretion when they are older." But every appearance of amiable simplicity, or of honest shame, nature's hasty conscience, will be dear to sensible hearts; they will carefully cherish every such indication in a young female; for they will perceive that it is this temper, wisely cultivated, which will one day make her enamored of the loveliness of virtue, and the beauty of holiness; from which she will acquire a taste for the doctrines of religion, and a spirit to perform the duties of it. And those who wish to make her ashamed of this charming temper, and seek to dispossess her of it, will, it is to be feared, give her nothing better in exchange. But whoever reflects at all, will easily discern how carefully this enthusiasm is to be directed, and how judiciously its redundances are to be lopped away.

Prudence is not natural to children; they can, however, substitute art in its stead. But is it not much better that a girl should

discover the faults incident to her age, than conceal them under this dark and impenetrable veil? I could almost venture to assert, that there is something more becoming in the very errors of nature, where they are undisguised, than in the affectation of virtue itself, where the reality is wanting. And I am so far from being an admirer of prodigies, that I am extremely apt to suspect them; and am always infinitely better pleased with nature in her more common modes of operation. The precise and premature wisdom which some girls have cunning enough to assume, is of a more dangerous tendency than any of their natural failings can be, as it effectually covers those secret bad dispositions, which, if they displayed themselves, might be rectified. The hypocrisy of assuming virtues which are not inherent in the heart, prevents the growth and disclosure of those real ones, which it is the great end of education to cultivate.

But if the natural indications of the temper are to be suppressed and stifled, where are the diagnostics by which the state of the mind is to be known? The wise Author of all things, who did nothing in vain, doubtless intended them as symptoms, by which to judge of the diseases of the heart; and it is impossible diseases should be cured before they are known. If the stream be so cut off as to prevent communication, or so choked up as to defeat discovery, how shall we ever reach the source, out of which are the issues of life?

This cunning, which, of all the different dispositions girls discover, is most to be dreaded, is increased by nothing so much as by fear. If those about them express violent and unreasonable anger at every trivial offence, it will always promote this temper, and will very frequently create it, where there was a natural tendency to frankness. The indiscreet transports of rage, which

many betray on every slight occasion, and the little distinction they make between venial errors and premeditated crimes, naturally dispose a child to conceal what she does not, however, care to suppress. Anger in one will not remedy the faults of another; for how can an instrument of sin cure sin? If a girl is kept in a state of perpetual and slavish terror, she will perhaps have artifice enough to conceal those propensities which she knows are wrong, or those actions which she thinks are most obnoxious to punishment. But, nevertheless, she will not cease to indulge those propensities, and to commit those actions, when she can do it with impunity.

Good *dispositions*, of themselves, will go but a very little way, unless they are confirmed into good *principles*. And this cannot be effected but by a careful course of religious instruction, and a patient and laborious cultivation of the moral temper.

But, notwithstanding girls should not be treated with unkindness, nor the first openings of the passions blighted by cold severity, yet I am of opinion that young females should be accustomed very early in life to a certain degree of restraint. The natural cast of character, and the moral distinctions between the sexes, should not be disregarded, even in childhood. That bold, independent, enterprizing spirit, which is so much admired in boys, should not, when it happens to discover itself in the other sex, be encouraged, but suppressed. Girls should be taught to give up their opinions betimes, and not pertinaciously to carry on a dispute, even if they should know themselves to be in the right. I do not mean, that they should be robbed of the liberty of private judgment, but that they should by no means be encouraged to contract a contentious or contradictory turn. It is of the greatest importance to their future happiness, that they should acquire a

submissive temper and a forbearing spirit; for it is a lesson which the world will not fail to make them frequently practise, when they come abroad into it, and they will not practise it the worse for having learnt it the sooner. These restraints, in the limitation here meant, are so far from being an effect of cruelty, that they are the most indubitable marks of affection, and are the more meritorious, as they are severe trials of tenderness. But all the beneficial effects, which a mother can expect from this watchfulness, will be entirely defeated, if it is practised occasionally, and not habitually, and if it ever appears to be used to gratify caprice, ill-humor, or resentment.

Those who have children to educate ought to be extremely patient: it is indeed a labor of love. They should reflect, that extraordinary talents are neither essential to the well-being of society, nor to the happiness of individuals. If that had been the case, the beneficent Father of the universe would not have made them so rare. For it is as easy for an almighty Creator to produce a Newton, as an ordinary man; and he could have made those powers common which we now consider as wonderful, without any miraculous exertion of his omnipotence, if the existence of many Newtons had been necessary to the perfection of his wise and gracious plan.

Surely, therefore, there is more piety, as well as more sense, in laboring to improve the talents which children actually have, than in lamenting that they do not possess supernatural endowments or angelic perfections. A passage of Lord Bacon's furnishes an admirable incitement for endeavoring to carry the amiable and Christian grace of charity to its farthest extent, instead of indulging an over-anxious care for more brilliant but less important acquisitions. "The desire of power in excess (says

he) caused the angels to fall: the desire of knowledge in excess caused man to fall; but in charity is no excess, neither can men nor angels come into danger by it."

A girl who has docility will seldom be found to want understanding enough for all the purposes of a social, a happy, and a useful life. And when we behold the tender hope of fond and anxious love blasted by disappointment, the defect will as often be discovered to proceed from the neglect or the error of cultivation, as from the natural temper; and those who lament the evil, will sometimes be found to have occasioned it.

It is as injudicious for parents to set out with too sanguine a dependence on the merit of their children, as it is for them to be discouraged at every repulse. When their wishes are defeated in this or that particular instance, where they had treasured up some darling expectation, this is so far from being a reason for relaxing their attention, that it ought to be an additional motive for redoubling it. Those who hope to do a great deal, must not expect to do every thing. If they know any thing of the malignity of sin, the blindness of prejudice, or the corruption of the human heart, they will also know, that that heart will always remain, after the very best possible education, full of infirmity and imperfection. Extraordinary allowances, therefore, must be made for the weakness of nature in this its weakest state. After much is done, much will remain to do, and much, very much, will still be left undone; for this regulation of the passions and affections cannot be the work of education alone, without the concurrence of divine grace operating on the heart. Why then should parents repine, if their efforts are not always crowned with immediate success? They should consider, that they are not educating cherubims and seraphims, but men and women; creatures, who, at

their best estate, are altogether vanity: how little then can be expected from them in the weakness and imbecility of infancy! I have dwelt on this part of the subject the longer, because I am certain that many, who have set out with a warm and active zeal, have cooled on the very first discouragement, and have afterwards almost totally remitted their vigilance, through a criminal kind of despair.

Great allowances must be made for a profusion of gayety, loquacity, and even indiscretion in children, that there may be animation enough left to supply an active and useful character, when the first fermentation of the youthful passions is over, and the redundant spirits shall come to subside.

If it be true, as a consummate judge of human nature has observed,

That not a vanity is given in vain,

it is also true, that there is scarcely a single passion, which may not be turned to some good account, if prudently rectified, and skilfully turned into the road of some neighboring virtue. It cannot be violently bent, or unnaturally forced towards an object of a totally opposite nature, but may be gradually inclined towards a correspondent but superior affection. Anger, hatred, resentment, and ambition, the most restless and turbulent passions which shake and distract the human soul, may be led to become the most active opposers of sin, after having been its most successful instruments.

Our anger, for instance, which can never be totally subdued, may be made to turn against ourselves, for our weak and imperfect obedience – our hatred against every species of vice – our

ambition, which will not be discarded, may be ennobled: it will not change its name, but its object; it will despise what it lately valued, nor be contented to grasp at less than immortality.

Thus the joys, fears, hopes, desires, all the passions and affections, which separate in various currents from the soul, will, if directed into their proper channels, after having fertilized wherever they have flowed, return again to swell and enrich the parent source.

That the very passions which appear the most uncontrollable and unpromising, may be intended, in the great scheme of Providence, to answer some important purpose, is remarkably evidenced in the character and history of Saint Paul. A remark on this subject by an ingenious old Spanish writer, which I will here take the liberty to translate, will better illustrate my meaning.

"To convert the bitterest enemy into the most zealous advocate, is the work of God for the instruction of man. Plutarch has observed, that the medical science would be brought to the utmost perfection, when poison should be converted into physic. Thus, in the mortal disease of Judaism and idolatry, our blessed Lord converted the adder's venom of Saul the persecutor into that cement which made Paul the chosen vessel. That manly activity, that restless ardor, that burning zeal for the law of his fathers, that ardent thirst for the blood of Christians, did the Son of God find necessary in the man who was one day to become the defender of his suffering people."[1]

To win the passions, therefore, over to the cause of virtue, answers a much nobler end than their extinction would possibly do, even if that could be effected. But it is their nature never to observe a neutrality; they are either rebels or auxiliaries, and an enemy subdued is an ally obtained. If I may be allowed to change

the allusion so soon, I would say, that the passions also resemble fires, which are friendly and beneficial when under proper direction, but if suffered to blaze without restraint, they carry devastation along with them, and, if totally extinguished, leave the benighted mind in a state of cold and comfortless inanity.

But, in speaking of the usefulness of the passions, as instruments of virtue, envy and lying must always be excepted: these, I am persuaded, must either go on in still progressive mischief, or else be radically cured, before any good can be expected from the heart which has been infected with them. For I never will believe that envy, though passed through all the moral strainers, can be refined into a virtuous emulation, or lying improved into an agreeable turn for innocent invention. Almost all the other passions may be made to take an amiable hue; but these two must either be totally extirpated, or be always contented to preserve their original deformity, and to wear their native black.

Endnotes - Chapter 6

1 Obras de Quevedo, vida de San Pablo Apostol. [Francisco Quevedo de Villegas, born at Villeneuve d'l Infantado, in Spain, in 1570, and died there in 1645. His works, printed at Brussels (3 vols.), consist of poems, romances, satires, and some religious pieces, among which is the one here quoted. – E.D. J

7

On the Importance of Religion to the Female Character

VARIOUS are the reasons why the greater part of mankind cannot apply themselves to arts or letters. Particular studies are only suited to the capacities of particular persons. Some are incapable of applying to them from the delicacy of their sex, some from the unsteadiness of youth, and others from the imbecility of age. Many are precluded by the narrowness of their education, and many by the straitness of their fortune. The wisdom of God is wonderfully manifested in this happy and well-ordered diversity in the powers and properties of his creatures; since, by thus admirably suiting the agent to the action, the whole scheme of human affairs is carried on with the most agreeing and consistent economy, and no chasm is left for want of an object to fill it, exactly suited to its nature.

But in the great and universal concern of religion, both sexes, and all ranks, are equally interested. The truly catholic spirit of Christianity accommodates itself, with an astonishing conde-

scension, to the circumstances of the whole human race. It rejects none on account of their pecuniary wants, their personal infirmities, or their intellectual deficiencies. No superiority of parts is the least recommendation, nor is any depression of fortune the smallest objection. None are too wise to be excused from performing the duties of religion, nor are any too poor to be excluded from the consolations of its promises.

If we admire the wisdom of God, in having furnished different degrees of intelligence, so exactly adapted to their different destinations, and in having fitted every part of his stupendous work, not only to serve its own immediate purpose, but also to contribute to the beauty and perfection of the whole, how much more ought we to adore that goodness which has perfected the divine plan, by appointing one wide, comprehensive, and universal means of salvation! A salvation which all are invited to partake, by a means which all are capable of using; which nothing but voluntary blindness can prevent our comprehending, and nothing but wilful error can hinder us from embracing.

The muses are coy, and will only be wooed and won by some highly-favored suitors. The sciences are lofty, and will not stoop to the reach of ordinary capacities. But "wisdom (by which the royal preacher means piety) is a loving spirit; she is easily seen of them that love her, and found of all such as seek her." Nay, she is so accessible and condescending, "that she preventeth them that desire her, making herself first known unto them."

We are told by the same animated writer, "that wisdom is the breath of the power of God." How infinitely superior, in grandeur and sublimity, is this description to the origin of the *wisdom* of the heathens, as described by their poets and mythologists! In the exalted strains of the Hebrew poetry, we read, that "wisdom

is the brightness of the everlasting light, the unspotted mirror of the power of God, and the image of his goodness."

The philosophical author of "The Defence of Learning" observes, that knowledge has something of venom and malignity in it, when taken without its proper corrective; and what that is, the inspired Saint Paul teaches us, by placing it as the immediate antidote – "Knowledge puffeth up, but charity edifieth." Perhaps it is the vanity of human wisdom, unchastised by this correcting principle, which has made so many infidels. It may proceed from the arrogance of a self-sufficient pride, that some philosophers disdain to acknowledge their belief in a Being, who has judged proper to conceal from them the infinite wisdom of his counsels; who (to borrow the lofty language of the man of Uz) refused to consult them when he laid the foundations of the earth, when he shut up the sea with doors, and made the clouds the garment thereof.

A man must be an infidel either from pride, prejudice, or bad education: he cannot be one unawares, or by surprise; for infidelity is not occasioned by sudden impulse or violent temptation. He may be hurried by some vehement desire into an immoral action, at which he will blush in his cooler moments, and which he will lament as the sad effect of a spirit unsubdued by religion; but infidelity is a calm, considerate act, which cannot plead the weakness of the heart, or the seduction of the senses. Even good men frequently fail in their duty, through the infirmities of nature, and the allurements of the world; but the infidel errs on a plan, on a settled and deliberate principle.

But though the minds of men are sometimes fatally infected with this disease, either through unhappy prepossession, or some of the other causes above mentioned, yet I am unwilling

to believe that there is in nature so monstrously incongruous a being as a *female* infidel. The least reflection on the temper, the character, and the education of women, makes the mind revolt with horror from an idea so improbable and so unnatural.

May I be allowed to observe that, in general, the minds of girls seem more aptly prepared in their early youth for the reception of serious impressions than those of the other sex, and that their less exposed situations in more advanced life qualify them better for the preservation of them? The daughters (of good parents, I mean) are often more carefully instructed in their religious duties than the sons, and this from a variety of causes. They are not so soon sent from under the paternal eye into the bustle of the world, and so early exposed to the contagion of bad example: their hearts are naturally more flexible, soft, and liable to any kind of impression the forming hand may stamp on them; and, lastly, as they do not receive the same classical education with boys, their feeble minds are not obliged at once to receive and separate the precepts of Christianity and the documents of pagan philosophy. The necessity of doing this perhaps somewhat weakens the serious impressions of young men, at least till the understanding is formed; and confuses their ideas of piety, by mixing them with so much heterogeneous matter. They only casually read, or hear read, the Scriptures of truth, while they are obliged to learn by heart, construe and repeat, the poetical fables of the less than human gods of the ancients. And, as the excellent author of "The Internal Evidence of the Christian Religion"[1] observes, "Nothing has so much contributed to corrupt the true spirit of the Christian institution, as that partiality which we contract, in our earliest education, for the manners of pagan antiquity."

Girls, therefore, who do *not* contract this early partiality,

ought to have a clearer notion of their religious duties: they are not obliged, at an age when the judgment is so weak, to distinguish between the doctrines of Zeno, of Epicurus, and of Christ; and to embarrass their minds with the various morals which were taught in the Porch, in the Academy, and on the Mount.

It is presumed that these remarks cannot possibly be so misunderstood, as to be construed into the least disrespect to literature, or a want of the highest reverence for a learned education, the basis of all elegant knowledge: they are only intended, with all proper deference, to point out to young women that, however inferior their advantages of acquiring a knowledge of the belles-lettres are to those of the other sex, yet it depends on themselves not to be surpassed in this most important of all studies, for which their abilities are equal, and their opportunities perhaps greater.

But the mere exemption from infidelity is so small a part of the religious character, that I hope no one will attempt to claim any merit from this negative sort of goodness, or value herself merely for not being the very worst thing she possibly can be. Let no mistaken girl fancy she gives a proof of her wit by her want of piety, or that a contempt of things serious and sacred will exalt her understanding, or raise her character, even in the opinion of the most avowed male infidels. For one may venture to affirm, that with all their profligate ideas, both of women and of religion, neither Bolingbroke, Wharton, Buckingham, nor even Lord Chesterfield himself, would have esteemed a woman the more for her being irreligious.

With whatever ridicule a polite freethinker may affect to treat religion himself, he will think it necessary his wife should entertain different notions of it. He may pretend to despise it as a

matter of opinion, depending on creeds and systems; but, if he is a man of sense, he will know the value of it, as a governing principle, which is to influence her conduct and direct her actions. If he sees her unaffectedly sincere in the practice of her religious duties, it will be a secret pledge to him that she will be equally exact in fulfilling the conjugal; for he can have no reasonable dependence on her attachment to *him*, if he has no opinion of her fidelity to God; for she who neglects first duties gives but an indifferent proof of her disposition to fill up inferior ones; and how can a man of any understanding (whatever his own religious professions may be) trust that woman with the care of his family, and the education of his children, who wants herself the best incentive to a virtuous life, the belief that she is an accountable creature, and the reflection that she has an immortal soul.

Cicero spoke it as the highest commendation of Cato's character, that he embraced philosophy, not for the sake of *disputing* like a philosopher, but of *living* like one. The chief purpose of Christian knowledge is to promote the great end of a Christian life. Every rational woman should, no doubt, be able to give a reason of the hope that is in her; but this knowledge is best acquired, and the duties consequent on it best performed, by reading books of plain piety and practical devotion, and not by entering into the endless feuds, and engaging in the unprofitable contentions, of partial controversialists. Nothing is more unamiable than the narrow spirit of party zeal, nor more disgusting than to hear a woman deal out judgments, and denounce vengeance, against any one who happens to differ from her in some opinion, perhaps of no real importance, and which, it is probable, she may be just as wrong in rejecting, as the object of her censure is in embracing. A furious and unmerciful female bigot wanders

as far beyond the limits prescribed to her sex, as a Thalestris or a Joan d'Arc. Violent debate has made as few converts as the sword, and both these instruments are particularly unbecoming when wielded by a female hand.

But, though no one will be frightened out of their opinions, yet they may be persuaded out of them: they may be touched by the affecting earnestness of serious conversation, and allured by the attractive beauty of a consistently serious life. And while a young woman ought to dread the name of a wrangling polemic, it is her duty to aspire after the honorable character of a sincere Christian. But this dignified character she can by no means deserve, if she is ever afraid to avow her principles, or ashamed to defend them. A profligate, who makes it a point to ridicule every thing which comes under the appearance of formal instruction, will be disconcerted at the spirited yet modest rebuke of a pious young woman. But there is as much efficacy in the manner of reproving profaneness, as in the words. If she corrects it with moroseness, she defeats the effect of her remedy, by her unskilful manner of administering it. If, on the other hand, she affects to defend the insulted cause of God in a faint tone of voice, and studied ambiguity of phrase, or with an air of levity, and a certain expression of pleasure in her eyes, which proves she is secretly delighted with what she pretends to censure, she injures religion much more than he did who publicly profaned it; for she plainly indicates, either that she does not believe or respect what she professes. The other attacked it as an open foe; she betrays it as a false friend. No one pays any regard to the opinion of an avowed enemy; but the desertion or treachery of a professed friend is dangerous indeed!

It is a strange notion, which prevails in the world, that re-

ligion only belongs to the old and the melancholy, and that it is not worth while to pay the least attention to it, while we are capable of attending to any thing else. They allow it to be proper enough for the clergy, whose business it is, and for the aged, who have not spirits for any business at all. But till they can prove, that none except the clergy and the aged *die*, it must be confessed that this is most wretched reasoning.

Great injury is done to the interests of religion, by placing it in a gloomy and unamiable light. It is sometimes spoken of, as if it would actually make a handsome woman ugly, or a young one wrinkled. But can any thing be more absurd than to represent the beauty of holiness as the source of deformity?

There are few, perhaps, so entirely plunged in business, or absorbed in pleasure, as not to intend, at some future time, to set about a religious life in good earnest. But then they consider it as a kind of *dernier ressort*, and think it prudent to defer flying to this disagreeable refuge till they have no relish left for any thing else. Do they forget, that to perform this great business well requires all the strength of their youth, and all the vigor of their unimpaired capacities? To confirm this assertion, they may observe how much the slightest indisposition, even in the most active season of life, disorders every faculty, and disqualifies them for attending to the most ordinary affairs; and then let them reflect how little able they will be to transact the most important of all business, in the moment of excruciating pain, or in the day of universal debility.

When the senses are palled with excessive gratification; when the eye is tired with seeing, and the ear with hearing; when the spirits are so sunk, that the *grasshopper is become a burden*, how shall the blunted apprehension be capable of understanding a

new science, or the worn-out heart be able to relish a new plea-sure?

To put off religion till we have lost all taste for amusement; to refuse listening to the voice of the charmer, till our enfeebled organs can no longer listen to the voice of "singing men and singing women," and not to devote our days to heaven till we have "no pleasure in them" ourselves, is but an ungracious offering. And it is a wretched sacrifice to the God of heaven, to present him with the remnants of decayed appetites, and the leavings of extinguished passions.

Endnotes – Chapter 7

1 Soame Jenyns, Esq.

8

Miscellaneous Observations on Genius, Taste, Good Sense, etc.

[1]GOOD *sense* is as different from *genius* as perception is from invention; yet, though distinct qualities, they frequently subsist together. It is altogether opposite to *wit*, but by no means inconsistent with it. It is not science, for there is such a thing as unlettered good sense; yet, though it is neither wit, learning, nor genius, it is a substitute for each where they do not exist, and the perfection of all where they do.

Good sense is so far from deserving the appellation of *common sense*, by which it is frequently called, that it is perhaps one of the rarest qualities of the human mind. If, indeed, this name is given it in respect to its peculiar suitableness to the purposes of common life, there is great propriety in it. Good sense appears to differ from taste in this, that taste is an instantaneous decision of the mind, a sudden relish of what is beautiful, or disgust at what is defective, in an object, without waiting for the slower confirmation of the judgment. Good sense is perhaps that con-

firmation which establishes a suddenly conceived idea, or feeling, by the powers of comparing and reflecting. They differ also in this, that taste seems to have a more immediate reference to arts, to literature, and to almost every object of the senses; while good sense rises to moral excellence, and exerts its influence on life and manners. Taste is fitted to the perception and enjoyment of whatever is beautiful in art or nature; good sense, to the improvement of the conduct, and the regulation of the heart.

Yet the term good sense is used indiscriminately to express either a finished taste for letters, or an invariable prudence in the affairs of life. It is sometimes applied to the most moderate abilities, in which case, the expression is certainly too strong; and at others to the most shining, when it is as much too weak and inadequate. A sensible man is the usual, but unappropriate phrase for every degree in the scale of understanding, from the sober mortal, who obtains it by his decent demeanor and solid dulness, to him whose talents qualify him to rank with a Bacon, a Harris, or a Johnson.

Genius is the power of invention and imitation. It is an incommunicable faculty: no art or skill of the possessor can bestow the smallest portion of it on another: no pains or labor can reach the summit of perfection, where the seeds of it are wanting in the mind; yet it is capable of infinite improvement where it actually exists, and is attended with the highest capacity of communicating instruction, as well as delight, to others.

It is the peculiar property of genius to strike out great or beautiful things: it is the felicity of good sense not to do absurd ones. Genius breaks out in splendid sentiments and elevated ideas; good sense confines its more circumscribed, but perhaps more useful walk, within the limits of prudence and propriety.

The poet's eye, in a fine frenzy rolling,
Doth glance from heaven to earth, from earth to heaven;
And, as imagination bodies forth
The forms of things unknown, the poet's pen
Turns them to shape, and gives to airy nothing
A local habitation and a name.[2]

This is, perhaps, the finest picture of human genius that ever was drawn by a human pencil. It presents a living image of a creative imagination, or a power of inventing things which have no actual existence.

With superficial judges, who, it must be confessed, make up the greater part of the mass of mankind, talents are only liked or understood to a certain degree. Lofty ideas are above the reach of ordinary apprehensions: the vulgar allow those who possess them to be in a somewhat higher state of mind than themselves; but of the vast gulf which separates them, they have not the least conception. They acknowledge a superiority, but of its extent they neither know the value, nor can conceive the reality. It is true, the mind, as well as the eye, can take in objects larger than itself; but this is only true of great minds; for a man of low capacity, who considers a consummate genius, resembles one, who, seeing a column for the first time, and standing at too great a distance to take in the whole of it, concludes it to be flat; or like one unacquainted with the first principles of philosophy, who, finding the sensible horizon appear a plain surface, can form no idea of the spherical form of the whole, which he does not see, and laughs at the account of antipodes, which he cannot comprehend.

Whatever is excellent is also rare; what is useful is more

common. How many thousands are born qualified for the coarse employments of life, for one who is capable of excelling in the fine arts! Yet so it ought to be, because our natural wants are more numerous, and more importunate, than the intellectual.

Whenever it happens that a man of distinguished talents has been drawn by mistake, or precipitated by passion, into any dangerous indiscretion, it is common for those whose coldness of temper has supplied the place and usurped the name of prudence, to boast of their own steadier virtue, and triumph in their own superior caution – only because they have never been assailed by a temptation strong enough to surprise them into error. And with what a visible appropriation of the character to themselves, do they constantly conclude with a cordial compliment to *common sense*! They point out the beauty and usefulness of this quality so forcibly and explicitly, that you cannot possibly mistake whose picture they are drawing with so flattering a pencil. The unhappy man whose conduct has been so feelingly arraigned, perhaps acted from good though mistaken motives; at least, from motives of which his censurer has not capacity to judge: but the event was unfavorable; nay, the action might be really wrong, and the vulgar maliciously take the opportunity of this single indiscretion, to lift themselves nearer on a level with a character which, except in this instance, has always thrown them at the most disgraceful and mortifying distance.

The elegant biographer of Collins, in his affecting apology for that unfortunate genius, remarks, "that the gifts of imagination bring the heaviest task on the vigilance of reason; and to bear those faculties with unerring rectitude, or invariable propriety, requires a degree of firmness, and of cool attention, which does not always attend the higher gifts of the mind; yet, difficult as

nature herself seems to have rendered the task of regularity to genius, it is the supreme consolation of dulness and of folly to point with Gothic triumph to those excesses which are the overflowing of faculties they never enjoyed."[3]

What the greater part of the world mean by common sense, will be generally found, on a closer inquiry, to be art, fraud, or selfishness! – That sort of saving prudence which makes men extremely attentive to their own safety or profit; diligent in the pursuit of their own pleasures or interests; and perfectly at their ease as to what becomes of the rest of mankind; furies, where their own property is concerned; philosophers, when nothing but the good of others is at stake; and perfectly resigned under all calamities but their own.

When we see so many accomplished wits of the present age, as remarkable for the decorum of their lives as for the brilliancy of their writings, we may believe that, next to principle, it is owing to their *good sense*, which regulates and chastises their imaginations. The vast conceptions which enable a true genius to ascend the sublimest heights, may be so connected with the stronger passions, as to give it a natural tendency to fly off from the straight line of regularity; till good sense, acting on the fancy, makes it gravitate powerfully towards that virtue which is its proper centre.

Add to this, when it is considered with what imperfection the divine wisdom has thought fit to stamp every thing human, it will be found that excellence and infirmity are so inseparably wound up in each other, that a man derives the soreness of temper, and irritability of nerve, which make him uneasy to others, and unhappy in himself, from those exquisite feelings, and that elevated pitch of thought, by which, as the apostle expresses it on

a more serious occasion, he is, as it were, out of the body.

It is not astonishing, therefore, when the spirit is carried away by the magnificence of its own ideas,

Not touched, but rapt; not wakened, but inspired,

that the frail body, which is the natural victim of pain, disease, and death, should not always be able to follow the mind in its aspiring flights, but should be as imperfect as if it belonged only to an ordinary soul.

Besides, might not Providence intend to humble human pride, by presenting to our eyes so mortifying a view of the weakness and infirmity of even his best work? Perhaps man, who is already but a little lower than the angels, might, like the revolted spirits, totally have shaken off obedience and submission to his Creator, had not God wisely tempered human excellence with a certain consciousness of its own imperfection. But though this inevitable alloy of weakness may frequently be found in the best characters, yet how can that be the source of triumph and exaltation to any, which, if properly weighed, must be the deepest motive of humiliation to all? A good-natured man will be so far from rejoicing, that he will be secretly troubled whenever he reads that the greatest Roman moralist was tainted with avarice, and the greatest British philosopher with venality.[4]

It is remarked by Pope, in his Essay on Criticism, that

Ten censure wrong for one who writes amiss.

But I apprehend it does not therefore follow that to judge is more difficult than to write. If this were the case, the critic would

be superior to the poet, whereas it appears to be directly the contrary. "The critic," says the great champion of Shakspeare,[5] "but fashions the body of a work; the poet must add the soul, which gives force and direction to its actions and gestures." It should seem that the reason why so many more judge wrong, than write ill, is, because the number of readers is, beyond all proportion, greater than the number of writers. Every man who reads, is in some measure a critic, and, with very common abilities, may point out real faults and material errors in a very well-written book; but it by no means follows that he is able to write any thing comparable to the work which he is capable of censuring. And unless the numbers of those who write, and of those who judge, were more equal, the calculation seems not to be quite fair.

A capacity for relishing works of genius is the indubitable sign of a good taste. But if a proper disposition and ability to enjoy the compositions of others, entitle a man to the claim of reputation, it is still a far inferior degree of merit to his who can invent and produce those compositions, the bare disquisition of which gives the critic no small share of fame.

The president of the royal academy,[6] in his admirable Discourse on Imitation, has set the folly of depending on unassisted genius in the clearest light, and has shown the necessity of adding the knowledge of others, to our own native powers, in his usual striking and masterly manner. "The mind," says he, "is a barren soil; is a soil soon exhausted, and will produce no crop, or only one, unless it be continually fertilized, and enriched with foreign matter."

Yet it has been objected, that study is a great enemy to originality; but, even if this were true, it would perhaps be as well that an author should give us the ideas of still better writers, mixed

and assimilated with the matter in his own mind, as those crude and undigested thoughts which he values under the notion that they are original. The sweetest honey neither tastes of the rose, the honey-suckle, nor the carnation, yet it is compounded of the very essence of them all.

If in the other fine arts this accumulation of knowledge is necessary, it is indispensably so in poetry. It is a fatal rashness for any one to trust too much to their own stock of ideas. He must invigorate them by exercise, polish them by conversation, and increase them by every species of elegant and virtuous knowledge, and the mind will not fail to reproduce with interest those seeds which are sown in it by study and observation. Above all, let every one guard against the dangerous opinion that he knows enough; an opinion that will weaken the energy and reduce the powers of the mind, which, though once perhaps vigorous and effectual, will be sunk to a state of literary imbecility, by cherishing vain and presumptuous ideas of its own independence.

For instance, it may not be necessary that a poet should be deeply skilled in the Linnæan system; but it must be allowed that a general acquaintance with plants and flowers will furnish him with a delightful and profitable species of instruction. He is not obliged to trace nature in all her nice and varied operations, with the minute accuracy of a Boyle or the laborious investigation of a Newton; but his good sense will point out to him that no inconsiderable portion of philosophical knowledge is requisite to the completion of his literary character. The sciences are more independent, and require little or no assistance from the graces of poetry; but poetry, if she would charm and instruct, must not be so haughty; she must be contented to borrow of the sciences many of her choicest allusions, and many of her most graceful

embellishments; and does it not magnify the character of true poesy, that she includes within herself all the scattered graces of every separate art?

The rules of the great masters in criticism may not be so necessary to the forming a good taste, as the examination of those original mines from whence they drew their treasures of knowledge.

The three celebrated essays on the art of poetry do not teach so much by their laws as by their examples; the dead letter of their rules is less instructive than the living spirit of their verse. Yet these rules are to a young poet what the study of logarithms is to a young mathematician: they do not so much contribute to form his judgment, as afford him the satisfaction of convincing him that he is right. They do not preclude the difficulty of the operation; but, at the conclusion of it, furnish him with a fuller demonstration that he has proceeded on proper principles. When he has well studied the masters in whose schools the first critics formed themselves, and fancies he has caught a spark of their divine flame, it may be a good method to try his own compositions by the test of the critic rules, so far indeed as the mechanism of poetry goes. If the examination be fair and candid, this trial, like the touch of Ithuriel's spear, will detect every latent error, and bring to light every favorite failing.

Good taste always suits the measure of its admiration to the merit of the composition it examines. It accommodates its praises, or its censure, to the excellence of a work, and appropriates it to the nature of it. General applause, or indiscriminate abuse, is the sign of a vulgar understanding. There are certain blemishes which the judicious and good-natured reader will candidly overlook. But the false sublime, the tumor which is intended

for greatness, the distorted figure, the puerile conceit, and the incongruous metaphor, – these are defects for which scarcely any other kind of merit can atone. And yet there may be more hope of a writer (especially if he be a young one), who is now and then guilty of some of these faults, than of one who avoids them all, not through judgment, but feebleness; and who, instead of deviating into error, is continually falling short of excellence. The mere absence of error implies that moderate and inferior degree of merit with which a cold heart and a phlegmatic taste will be better satisfied than with the magnificent irregularities of exalted spirits. It stretches some minds to an uneasy extension to be obliged to attend to compositions superlatively excellent; and it contracts liberal souls to a painful narrowness to descend to books of inferior merit. A work of capital genius, to a man of an ordinary mind, is the bed of Procrustes to one of a short stature – the man is too little to fill up the space assigned him, and undergoes the torture in attempting it: and a moderate or low production to a man of bright talents, is the punishment inflicted by Mezentius; the living spirit has too much animation to endure patiently to be in contact with a dead body.

Taste seems to be a sentiment of the soul which gives the bias to opinion, for we feel before we reflect. Without this sentiment, all knowledge, learning, and opinion, would be cold, inert materials; whereas they become active principles when stirred, kindled, and inflamed by this animating quality.

There is another feeling which is called enthusiasm. The enthusiasm of sensible hearts is so strong, that it not only yields to the impulse with which striking objects act on it, but such hearts help on the effect by their own sensibility. In a scene where Shakspeare and Garrick give perfection to each other, the feeling

heart does not merely accede to the delirium they occasion; it does more – it is enamored of it, it solicits the delusion, it sues to be deceived, and grudgingly cherishes the sacred treasure of its feelings. The poet and performer concur in carrying us

Beyond this visible diurnal sphere.

They bear us aloft in their airy course with unresisted rapidity, if they meet not with any obstruction from the coldness of our own feelings. Perhaps, only a few fine spirits can enter into the detail of their writing and acting; but the multitude do not enjoy less acutely, because they are not able philosophically to analyze the sources of their joy or sorrow. If the others have the advantage of judging, these have at least the privilege of feeling: and it is not from complaisance to a few leading judges, that they burst into peals of laughter, or melt into delightful agony; their hearts decide, and that is a decision from which there lies no appeal. It must, however, be confessed, that the nicer separations of character, and the lighter and almost imperceptible shades which sometimes distinguish them, will not be intimately relished, unless there be a consonancy of taste as well as feeling in the spectator; though, where the passions are principally concerned, the profane vulgar come in for a larger portion of the universal delight, than critics and connoisseurs are willing to allow them.

Yet enthusiasm, though the natural concomitant of genius, is no more genius itself, than drunkenness is cheerfulness; and that enthusiasm which discovers itself on occasions not worthy to excite it, is the mark of a wretched judgment and a false taste.

Nature produces innumerable objects: to imitate them is the province of genius; to direct those imitations is the property of

judgment; to decide on their effects is the business of taste. For taste, who sits as supreme judge on the productions of genius, is not satisfied when she merely imitates nature: she must also, says an ingenious French writer, imitate *beautiful* nature. It requires no less judgment to reject than to choose, and genius might imitate what is vulgar, under pretence that it was natural, if taste did not carefully point out those objects which are most proper for imitation. It also requires a very nice discernment to distinguish verisimilitude from truth; for there is a truth in taste nearly as conclusive as demonstration in mathematics.

Genius, when in the full impetuosity of its career, often touches on the very brink of error; and is, perhaps, never so near the verge of the precipice, as when indulging its sublimest flights. It is in those great, but dangerous moments, that the curb of vigilant judgment is most wanting; while safe and sober dulness observes one tedious and insipid round of tiresome uniformity, and steers equally clear of eccentricity and of beauty. Dulness has few redundancies to retrench, few luxuriances to prune, and few irregularities to smooth. These, though errors, are the errors of genius, for there is rarely redundancy without plenitude, or irregularity without greatness. The excesses of genius may easily be retrenched, but the deficiencies of dulness can never be supplied.

Those who copy from others will doubtless be less excellent than those who copy from nature. To imitate imitators is the way to depart too far from the great original herself. The latter copies of an engraving retain fainter and fainter traces of the subject, to which the earlier impressions bore so strong a resemblance.

It seems very extraordinary, that it should be the most difficult thing in the world to be natural; and that it should the most be harder to hit off the manners of real life, and to delineate such

characters as we converse with every day, than to imgine such as do not exist. But caricature is much easier than an exact outline, and the coloring of fancy less difficult than that of truth.

People do not always know what taste they have, till it is awakened by some corresponding object; nay, genius itself is a fire, which in many minds would never blaze, if not kindled by some external cause.

Nature, the munificent mother, when she bestows the power of judging, accompanies it with a capacity for enjoying. The judgment, which is clear-sighted, points out such objects as are calculated to inspire love, and the heart instantaneously attaches itself to whatever is lovely.

In regard to literary reputation, a great deal depends on the state of learning in the particular age or nation in which an author lives. In a dark and ignorant period, moderate knowledge will entitle its possessor to a considerable share of fame; whereas, to be distinguished in a polite and lettered age, requires striking parts and deep erudition.

When a nation begins to emerge from a state of mental darkness, and to strike out the first rudiments of improvement, it chalks out a few strong but incorrect sketches, gives the rude outlines of general art, and leaves the filling up to the leisure of happier days, and the refinement of more enlightened times. Their drawing is a rude schizzo, and their poetry wild minstrelsy.

Perfection of taste is a point which a nation no sooner reaches, than it overshoots; and it is more difficult to return to it, after having passed it, than it was to attain, when they fell short of it. Where the arts begin to languish after having flourished, they seldom indeed fall back to their original barbarism, but a certain feebleness of exertion takes place, and it is more difficult to

recover them from this dying languor to their proper strength, than it was to polish them from their former rudeness; for it is a less formidable undertaking to refine barbarity, than to stop decay: the first may be labored into elegance, but the latter will rarely be strengthened into vigor.

Taste exerts itself at first but feebly and imperfectly: it is repressed and kept back by a crowd of the most discouraging prejudices; like an infant prince, who, though born to reign, yet holds an idle sceptre, which he has not power to use, but is obliged to see with the eyes and hear through the ears of other men.

A writer of correct taste will hardly ever go out of his way, even in search of embellishment: he will study to attain the best end by the most natural means; for he knows that what is not natural cannot be beautiful, and that nothing can be beautiful out of its own place; for an improper situation will convert the most striking beauty into a glaring defect. When, by a well-connected chain of ideas, or a judicious succession of events, the reader is snatched to " Thebes or Athens," what can be more impertinent than for the poet to obstruct the operation of the passion he has just been kindling, by introducing a conceit which contradicts his purpose, and interrupts his business? Indeed, we cannot be transported, even in idea, to those places, if the poet does not manage so adroitly as not to make us sensible of the journey: the instant we feel we are travelling, the writer's art fails, and the delirium is at an end.

Proserpine, says Ovid, would have been restored to her mother Ceres, had not Ascalaphus seen her stop to gather a golden apple, when the terms of her restoration were, that she should taste nothing – a story pregnant with instruction for lively writers, who, by neglecting the main business, and going out of

the way for false gratifications, lose sight of the end they should principally keep in view. It was this false taste that introduced the numberless *concetti* which disgrace the brightest of the Italian poets; and this is the reason why the reader only feels short and interrupted snatches of delight in perusing the brilliant but unequal compositions of Ariosto,[7] instead of that unbroken and undiminished pleasure which he constantly receives from Virgil, from Milton, and generally from Tasso. The first-mentioned Italian is the Atalanta, who will interrupt the most eager career, to pick up the glittering mischief; while the Mantuan and the British bards, like Hippomenes, press on, warm in the pursuit, and unseduced by temptation.

A writer of real taste will take great pains, in the perfection of his style, to make the reader believe that he took none at all. The writing which appears to be most easy, will be generally found to be least imitable. The most elegant verses are the most easily retained: they fasten themselves on the memory, without its making any effort to preserve them; and we are apt to imagine that what is remembered with ease was written without difficulty.

To conclude: genius is a rare and precious gem, of which few know the worth; it is fitter for the cabinet of the connoisseur, than for the commerce of mankind. Good sense is a bank-bill, convenient for change, negotiable at all times, current in all places. It knows the value of small things, and considers that an aggregate of them makes up the sum of human affairs. It elevates common concerns into matters of importance, by performing them in the best manner, and at the most suitable season. Good sense carries with it the idea of equality, while genius is always suspected of a design to impose the burden of superiority; and respect is paid to it with that reluctance which always attends other imposts, the

lower orders of mankind generally repining most at demands by which they are least liable to be affected.

As it is the character of genius to penetrate with a lynx's beam into unfathomable abysses and uncreated worlds, and to see what is *not*, so it is the property of good sense to distinguish perfectly and judge accurately what really *is*. Good sense has not so piercing an eye, but it has as clear a sight: it does not penetrate so deeply, but as far as it *does* see, it discerns distinctly. Good sense is a judicious mechanic, who can produce beauty and convenience out of suitable means; but genius (I speak with reverence of the immeasurable distance) bears some remote resemblance to the divine Architect, who produced perfection of beauty without any visible materials: "who spake, and it was created;" who said, "Let it be, and it was."

Endnotes – Chapter 8

1 The author begs leave to offer an apology for introducing this essay, which, she fears, may be thought foreign to her purpose. But she hopes that her earnest desire of exciting a taste for literature in young ladies (which encouraged her to hazard the following remarks), will not obstruct her general design, even if it does not actually promote it.

2 Shakspeare's Midsummer Night's Dream, Act V. Scene 1st.

3 Dr. John Langhorne's Biographical Memoir, prefixed to the Poetical Works of Willian Collins.

4 Seneca and Bacon.

5 Mrs. Montagu, in her vindication of our immortal dramatist from the censorious remarks of Voltaire. – ED.

6 Sir Joshua Reynolds

7 Ariosto was born at Reggio in 1474, and died of grief in 1535. His principal work, the poetical romance of "Orlando Furioso," some of his admirers affected to set in opposition to the "Jerusalem Delivered" of Tasso. – ED.

About *The Greater Heritage*

Mission

The Greater Heritage is a Bible teaching and Christian publishing ministry that equips Christians for an abundant life of service, personal spiritual growth and character development through the study of God's Word and the contributions of His people in the fields of art, literature and music throughout history.

What We Do

The Greater Heritage publishes original articles, books and Bible studies. The ministry also hosts a podcast. All of its books are made entirely in the USA.

Want to publish with us? Inquire at:

The Greater Heritage
1170 Tree Swallow Dr., Suite 309
Winter Springs, Florida 32708
info@thegreaterheritage.com
www.thegreaterheritage.com

Find more books and our latest catalog online at:

www.thegreaterheritage.com/shop

CPSIA information can be obtained
at www.ICGtesting.com
Printed in the USA
BVHW051129090623
665684BV00016B/809